Faulkner's World: The Photographs of Martin J. Dain

Faulkner's World

Edited and with an Introduction by Tom Rankin • *Foreword by Larry Brown*

The Photographs of Martin J. Dain

THE FAULKNER CENTENNIAL EDITION

University Press of Mississippi / Jackson

Center for the Study of Southern Culture • The University of Mississippi / Oxford

Library of Congress Cataloging-in-Publication Data

Dain, Martin J.
 Faulkner's world : the photographs of Martin J. Dain /
edited and with an introduction by Tom Rankin ; foreword
by Larry Brown.
 p. cm.
 ISBN 1-57806-016-8 (alk. paper)
 1. Lafayette County (Miss.)—Pictorial works. 2. Faulkner,
William, 1897-1962—Home and haunts—Mississippi—Lafayette
County—Pictorial works. I. Rankin, Tom. II. Title.
F347.L2D33 1997
976.2'83—dc21
 97-13772
 CIP

British Library Cataloging-in-Publication data available

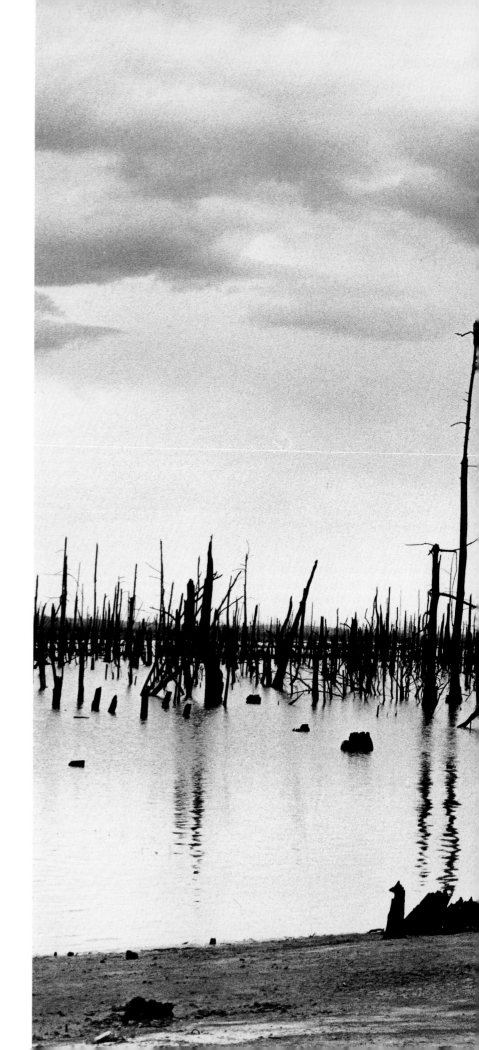

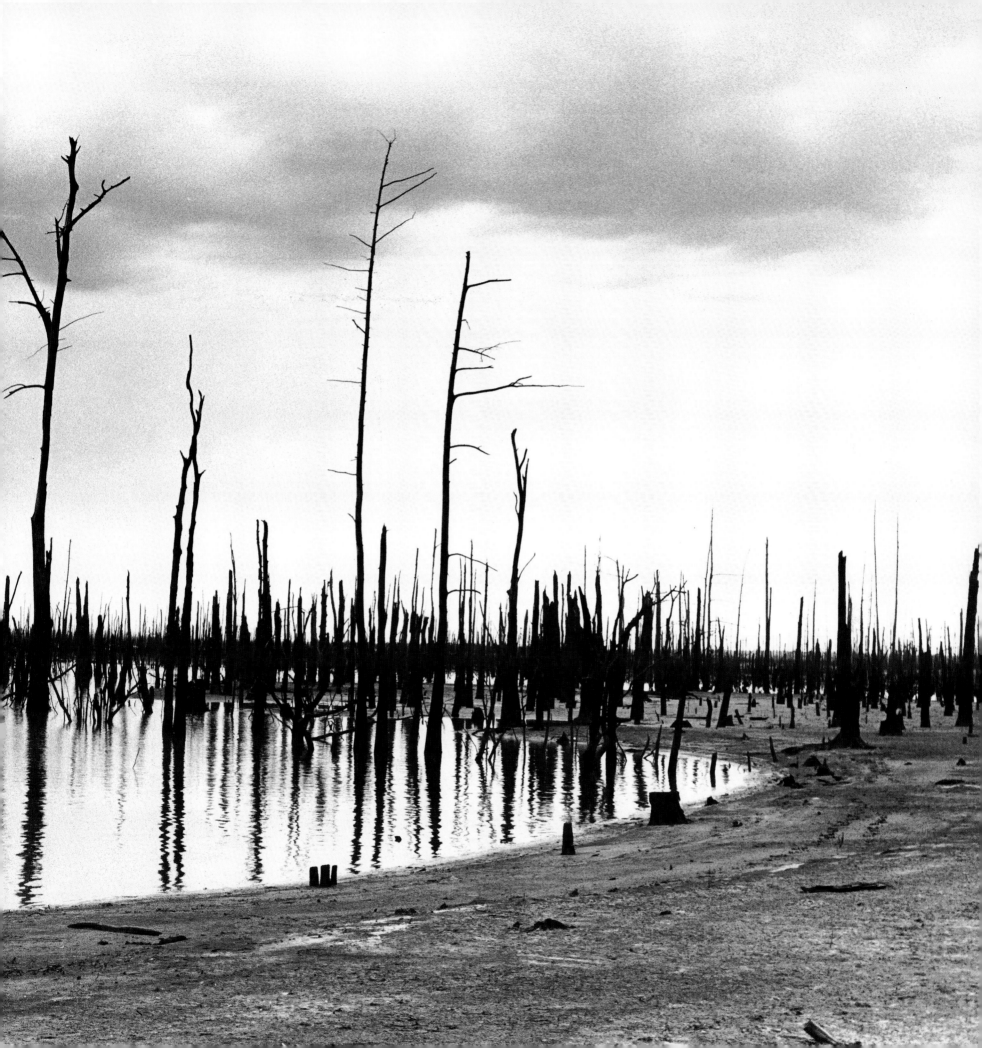

Foreword

Larry Brown

THESE IMAGES EVOKE another time in the place I still call home. The memories I hold of the period when the pictures were taken are not as sharp and clear as the photographs, but they come welling up stronger and stronger as I turn these pages. I see children I grew up with frozen in place more than thirty years back, and grown men and old people long dead and gone from this life. So much has changed, yet so much has remained the same: the roads, the courthouse, Rowan Oak, even some of the landscapes. Most of the big timber is gone now, the thick oaks and gums and hickories cut down and hauled away and replaced by pine forests, but out in the county small pockets of hunting woods remain for those who know these hidden places. The mules have gone, too, mostly, along with the farmers who used to plow them; I remember unpainted houses and the cooking smells inside them, the flat hearths, the yapping dogs and woodsmoke curling from the homemade chimneys, cold November afternoons picking cotton after school and dragging a long sack up a row of white bolls, dark coming fast, and the long walks home.

Mornings like those in the stories in Faulkner's *Big Woods* keep coming back to mind: spotted hounds and deep white frost on the leaves of the forest floor and cold so strong my legs shook inside the thin pants where I sat at a crossing, waiting for the dogs, their voices echoing through the wooded ridges like pealing bells and growing nearer and nearer. The roads where we hunted were all sand and gravel back then and they were bordered by stands of trees and cane and honeysuckle. Lunch was a stop at a country store and Vienna sausage and a nickel pack of crackers, some cheese and a small box of milk. Back then there was hunting all day, and we didn't quit until it was too dark to see, and then we dressed the deer by flashlight. These photos look like that time in my mind.

Abject poverty is in here, too, the poor people out in the sticks who had to work so hard to have so little, the ones who had to go to the post offices at Taylor or Tula or Paris or Oxford to get their commodities, butter and powdered eggs and milk and white rice and cereal, the staples. Many would have suffered empty bellies without that help. I ate that food, too, and there was no shame in it. Chopping in a cotton patch for four dollars a day, that was in these times, too. People lived a simpler life then and got by with much less. Boys rode their bicycles up and down all the blacktop roads and the dirt roads, too. They fished and hunted within walking distance of their houses. Boys like me took quilts from their mothers' closets and matches and utensils from the kitchens and they camped beside creeks and ponds with other boys, told lies and ghost stories late into the night, cooked the fish they'd caught in a black iron skillet. The country is still not far from town and you can find it once you get out on the country roads and see the farms and the cows and the vegetable gardens, boats in the backs of pickups, watermelon stands in the summer, coonhounds in pens.

It seems the town has not changed so much as you would expect with such a passage of time. The soldier still stands where he always did, and the trees are still there behind him, some of them, anyway. The stores still line the square and the stones on the courthouse steps are cupped from the feet of people who have passed up and down them for years. But there's more traffic in Oxford now. Friday afternoons are always bad. The old Henry Hotel is gone, the Ritz Theatre is gone, the Lyric, but the streets Faulkner walked still look almost the same. There are no parking meters now, just an officer with chalk on a stick who marks tires. I miss those parking meters. They marked this era that has passed as well as anything.

People don't seem to sit on the courthouse benches the way they used to. That's because all the old men who used

to sit there and talk are probably dead now. People are too busy now. Life moves faster now.

Life looks unhurried in Martin Dain's photos, people taking the time to stop and talk to their neighbors and friends. Leaning against a post, or a fire hydrant, or a wall, and sharing the news, or a laugh. On Saturdays they sold produce from the backs of trucks parked on the square and everybody made their weekly shopping trips to town. There were little 5 and 10 cent stores like The Golden Rule. Big Star sat where Gold's Gym is now. These pictures were probably made before The Mansion burned down, that old restaurant where Faulkner used to go at night and drink coffee.

Maybe the old houses are what I miss most, the ones with a breezeway through the middle and rooms on both sides. They were common when I was growing up, but you can barely find one now. There used to be an old man I hunted with and he lived in one those houses. The hallway would be just as cold as the outside world, yet you could open the door on the right and be immediately enveloped in warm air, the smells of whiskey, coffee, tobacco. Behind his rocking chair the wood floor was covered by a forest of deer horns, some old, some new, silent testimony to his prowess with dog and gun. Some of the houses in these pictures are like that house. So much has gone, so much has changed, so much has stayed the same. The time goes by so fast. You turn around and your children are grown, your parents old. The cycle keeps being completed.

Young people can learn from these pictures, as my kids already have, seeing things they've never seen before, or how things were so many years ago. I can remember being fascinated in the same way by the stacks of old pictures my mother keeps in a shoebox, she and my father and aunts and uncles standing beside the ancient cars and motorcycles in their youth, the old-fashioned dresses and the snap brim hats, the dust on the shining cars, the great war still ahead of them, the misery of it yet unknown. Long before I was, and I wonder how it was for them, what their lives were like, if theirs were harder or easier or better or worse than mine.

Stepping back into the past is like a dream world that once was real but now is gone, the faces faded and dulled by time in the memory. There are some things you wouldn't want to live through again and some things you'd give almost anything to have once more. Bad memories and the happiest of events all mixed together and days that are just glimpses now, the little details all but forgotten and some that you'll never be able to call back again. The life that you've had reaches so far back into the dim recesses of memory and into the places where the world was so gray and vague, and you were so young you can't recall it exactly, try as you might. You try to tell your children about your own childhood and it's like another planet to them. You remember the old people you used to talk to and you wish you could talk to them one more time. You know how valuable that was now.

These pictures preserve old times and people in the best and most satisfying ways. They can never fade away now, cannot slide back into memory to be forgotten forever. The river of time keeps moving and you move with it, changing, growing, still clinging to part of the past, the things that shaped and molded you and made you what you are today, but always looking ahead, when tomorrow will be today, and life will be one still piece of time, like a photograph, a clip, a monument from the years. You keep moving in the river of life, once in a while stopping to look back at what was, and marvel, and finally smile.

Evoking William Faulkner

Tom Rankin

"I CAN'T REMEMBER A TIME," recalled Martin J. Dain, "when I didn't read Faulkner. . . . All my life I had been reading Faulkner, and you mature along with your reading and you discover that this man has said and known everything that's worth knowing and saying in your entire life." Martin Dain could not say precisely when he began reading William Faulkner or when he became enamored with the world of Faulkner's mythical county, Yoknapatawpha. A commercial photographer who lived and worked in New York City, Dain eventually decided to pursue his abiding interest in Faulkner by traveling to Mississippi to photograph the writer's world. "I asked various people," Dain recalled. "If I go to Mississippi, am I going to be able to show this country? Will I be able to find things that will evoke a great author? Evoke is the key word. Don't take the pictures literally. Evoke." His desire to evoke the life and place of William Faulkner was the result of his professional interest in photography combined with a belief that Faulkner was "undoubtedly to me the greatest author in this country and maybe the world. There was no subject," Dain added, "that he didn't somehow touch."

Not a Mississippian, not a Southerner, not much of a student, Martin Dain can be seen as an unlikely Faulkner enthusiast. Born in Boston, Massachusetts, in 1924, he was the son of a pharmacist who worked in Cambridge. His father, a Russian Jew, had come to this country when he was in his mid-to-late teens. Probably middle class in Russia, he eventually located his family in Brookline, Massachusetts, and commuted to Dain's Pharmacy near Massachusetts Institute of Technology in Cambridge. Martin Dain received a solid education at the Boston Latin School and was probably expected to matriculate at one of the Ivy League colleges as his brother and cousins had done. But World War II forced him to enlist in the military, where he

served as a communications specialist from 1943 to 1946. "The state of Massachusetts had a thing that if you were eighteen years old and a senior with passing grades in high school and enlisted voluntarily you'd get a diploma," Dain said. "And that's what I did. 'Cause I wasn't doing well in school by any means. Boston Latin, that's a very damn tough place. I got out. I enlisted in '43. So it was '46 before I went to college."

Dain's interest in photography is nearly as hard to trace and date as his interest in reading the stories and books of William Faulkner. He has some wonderful small portraits showing his father as a young man in Russia. Photographs, particularly family images, were always important to the Dains, and Martin Dain's father welcomed photography in the home. "My father's hobby was photography," he recounted. "It was part of his therapy. In '36 he got his first Rolleicord, I think. It may have been his last one. Had only one camera. But we always, the family had a camera of some sort. I had a 1934 Brownie, anniversary model. I sold it. A box thing. We all had a camera. That's what I first used. Then I think I had my father's Rolleicord."

After the war, Martin Dain attended the University of Miami where he studied history and government and, among other things, organized the Henry Wallace for President effort at the school. Wallace, running against Truman in the 1948 election, impressed Dain with his progressive, inclusive platform. "I was socially conscious," Dain said. "And he was the only man that represented the people. He was a farmer and my hero then."

When he left the university it was to continue his studies under the auspices of the GI Bill in Paris, France. Perhaps still searching for his vocation and his passion, Dain joined a number of other American, college-aged students when he enrolled at the Sorbonne. He registered for classes but

Martin Dain, Carmel, California, 1996. *Photograph by Tom Rankin.*

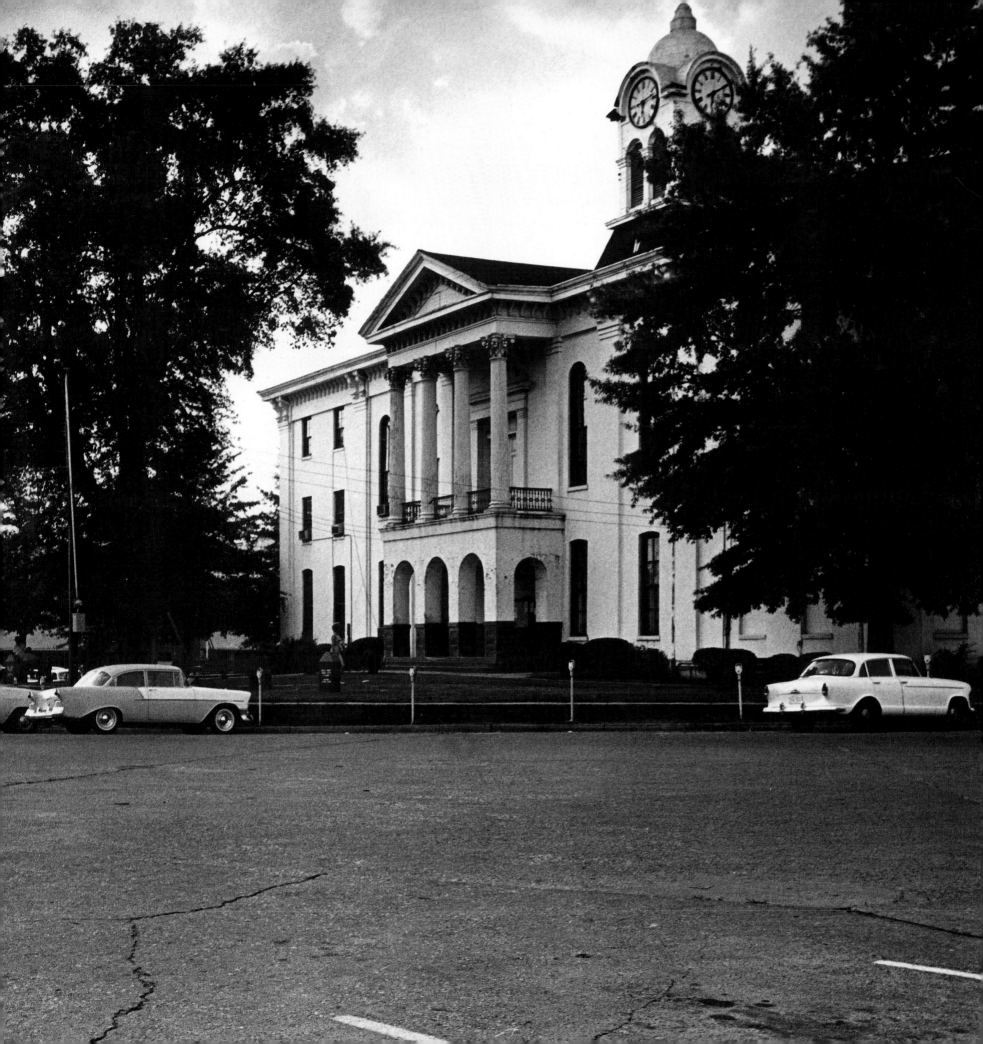

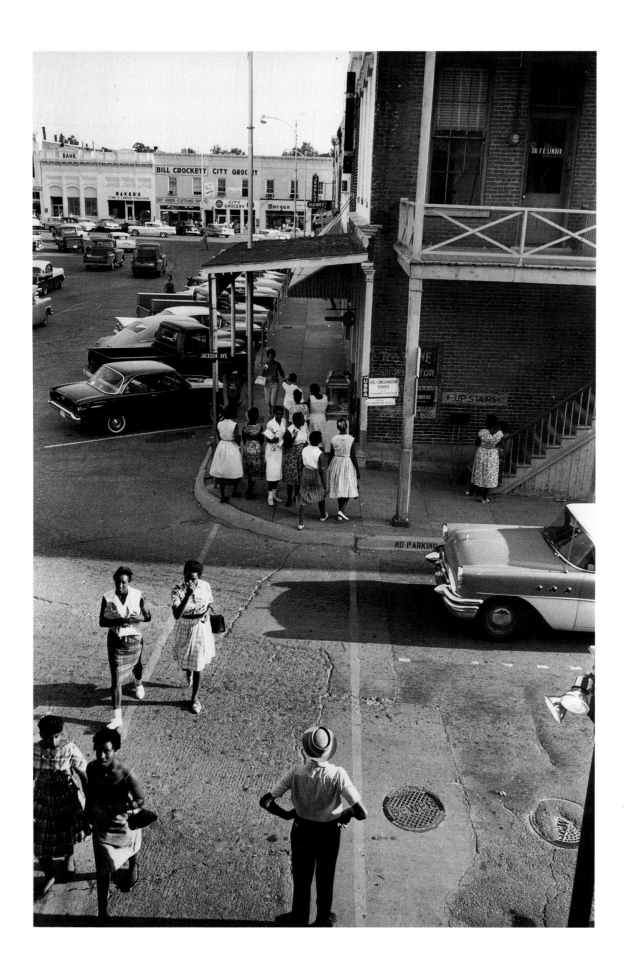

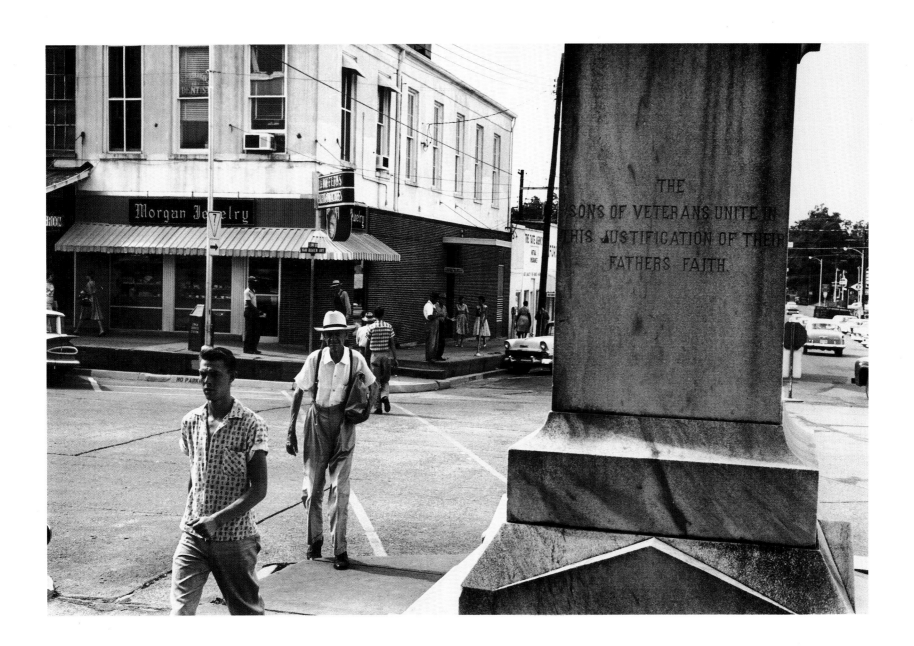

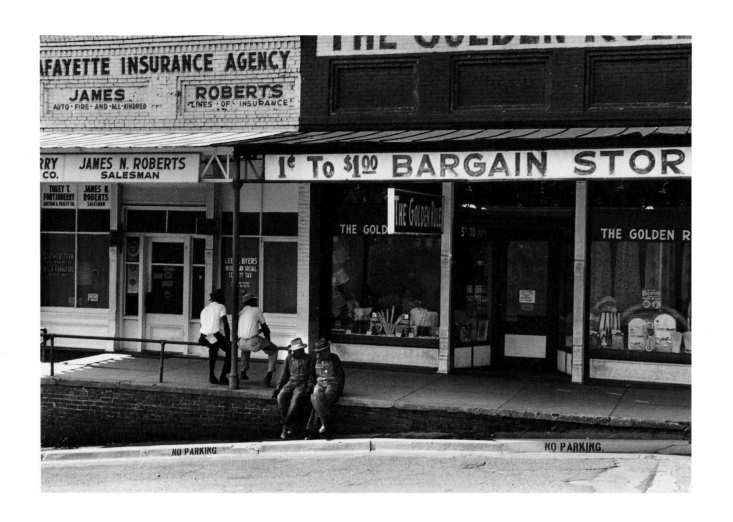

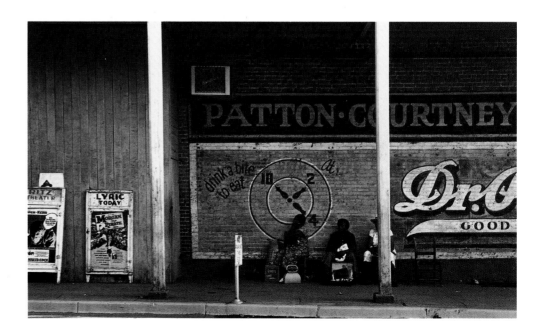

22

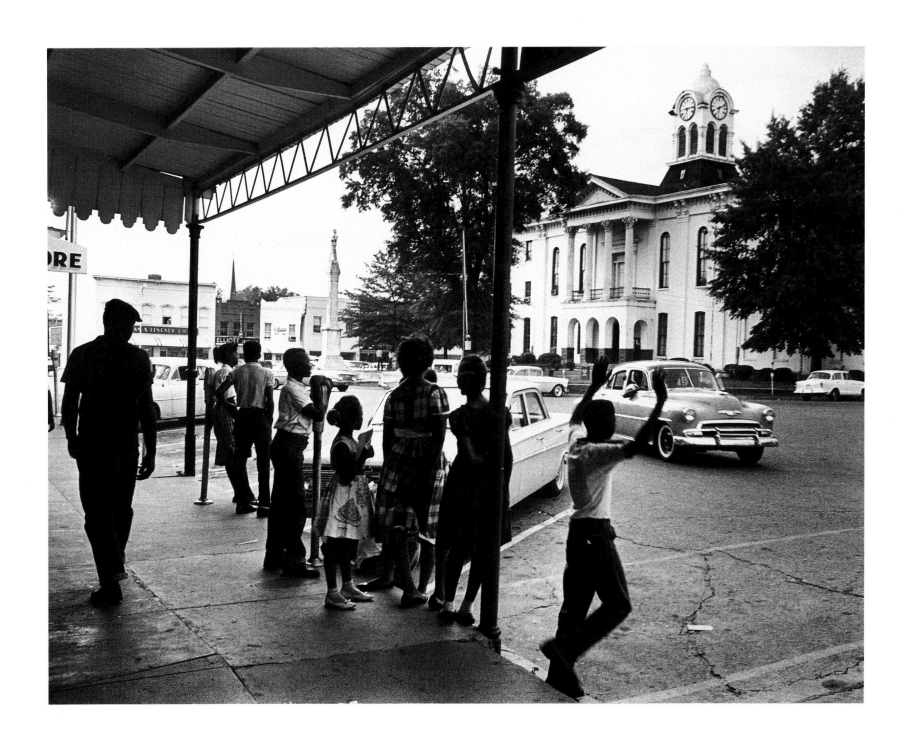

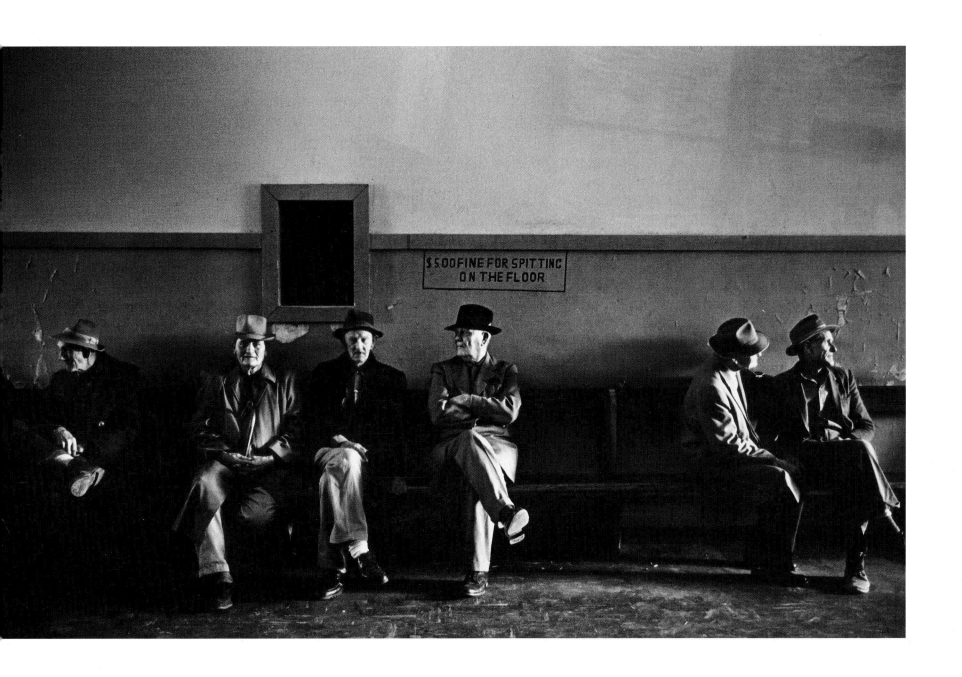

24

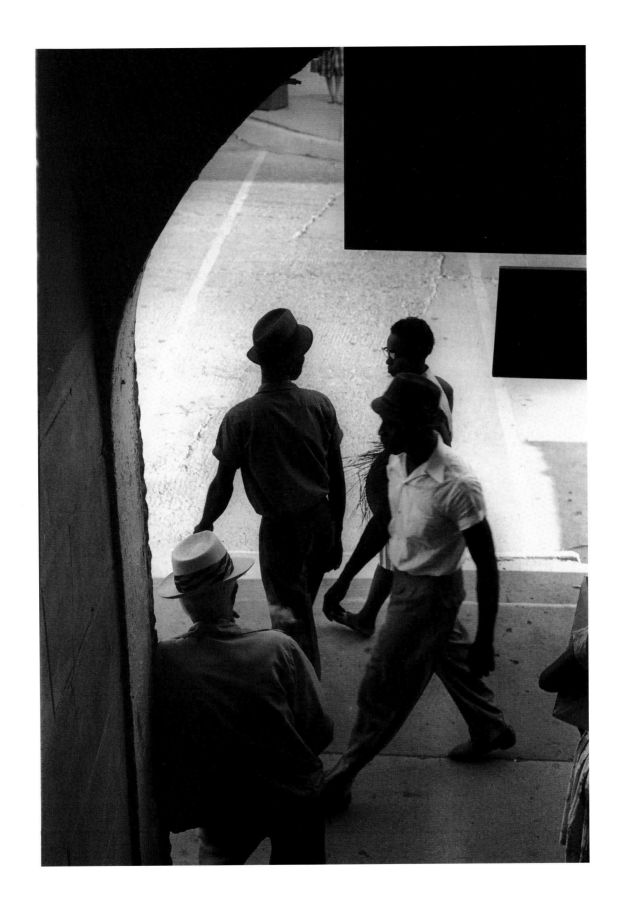

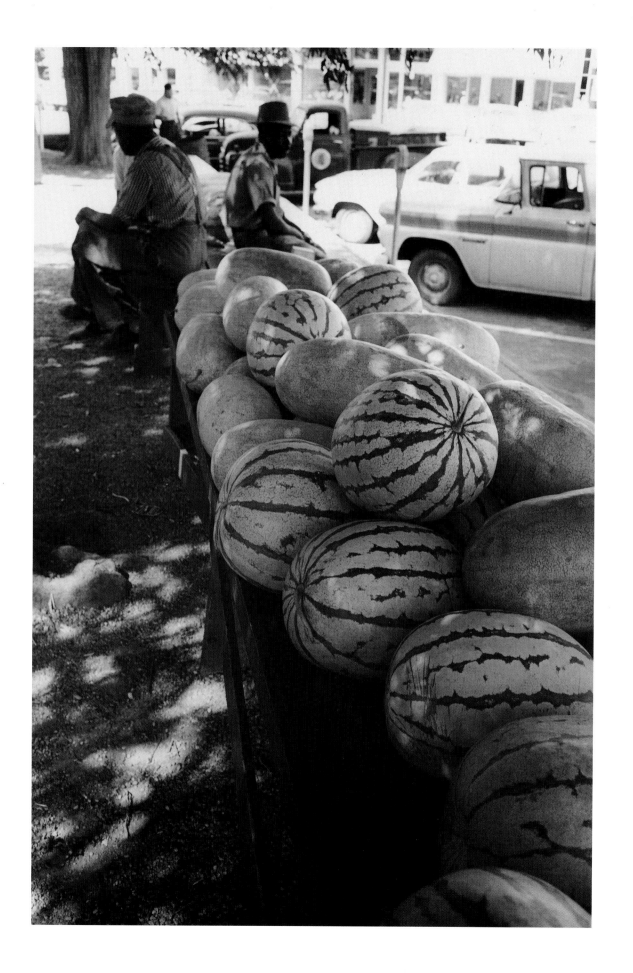

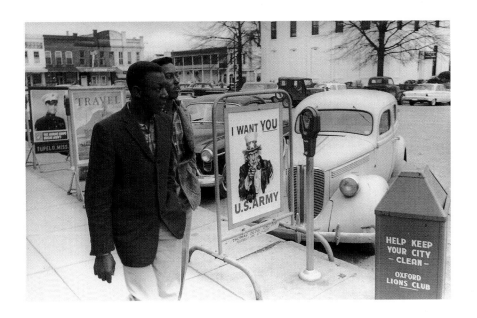

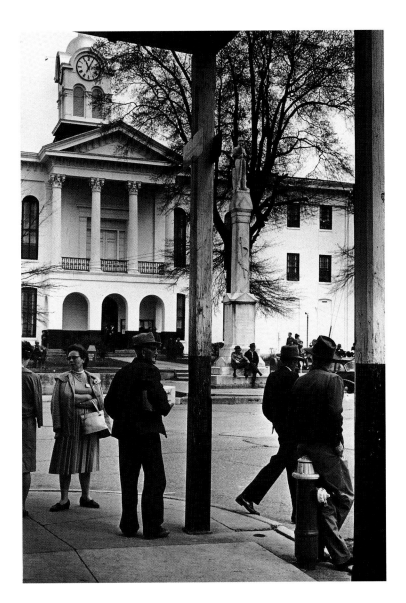

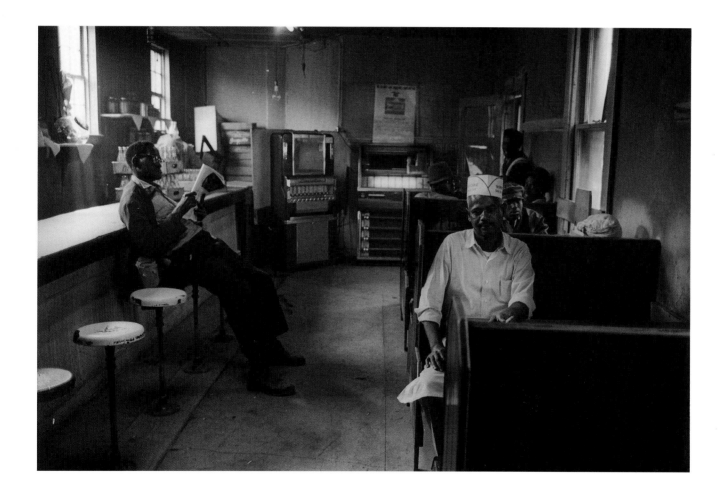

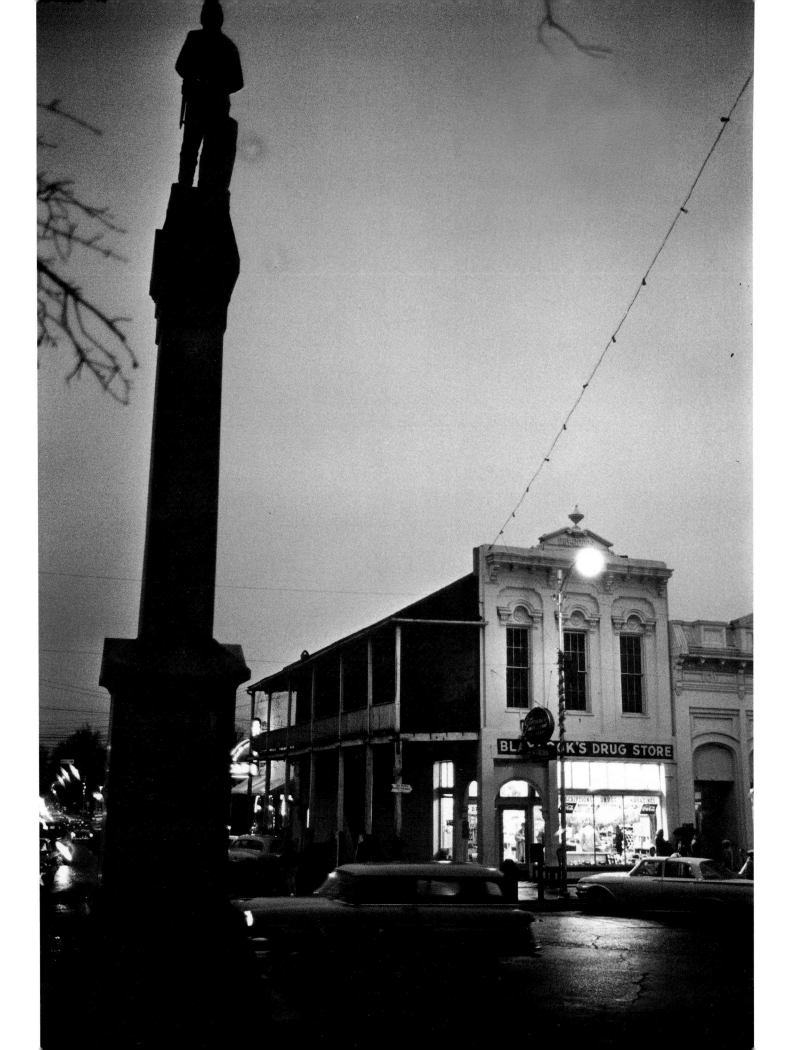

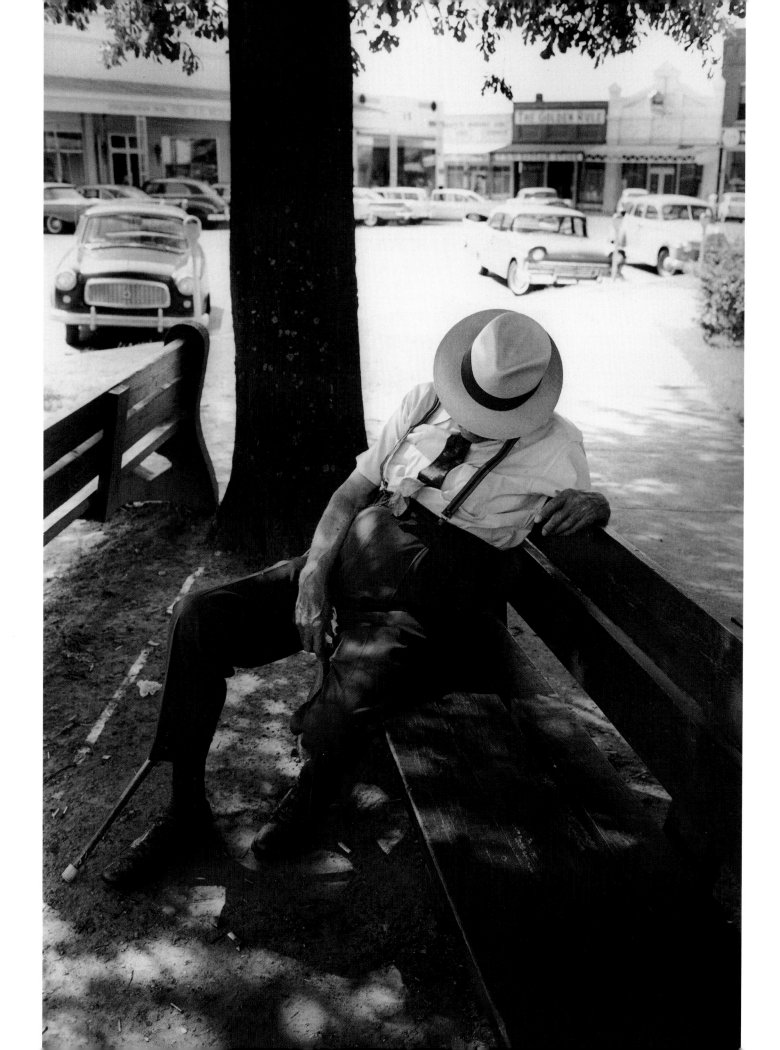

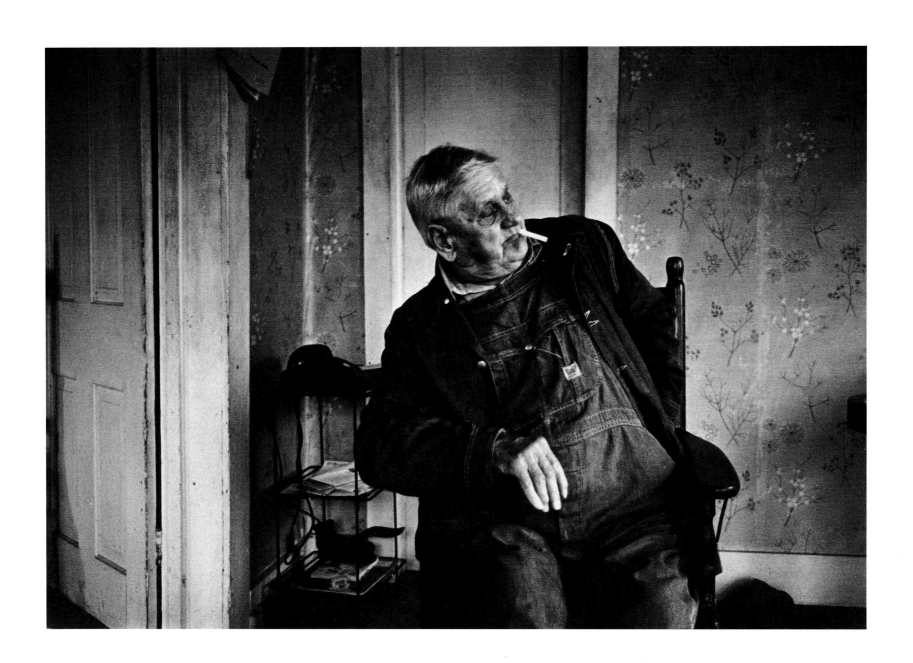

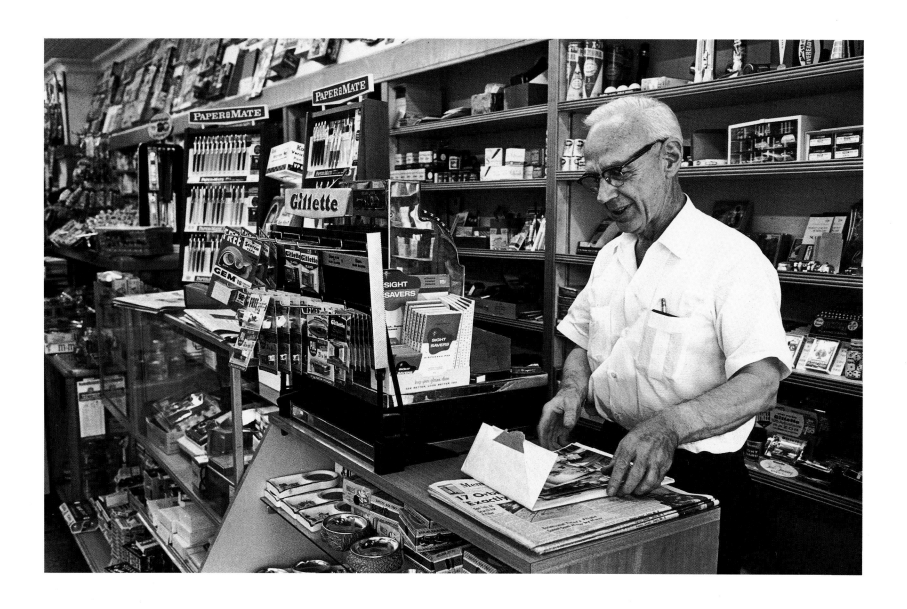

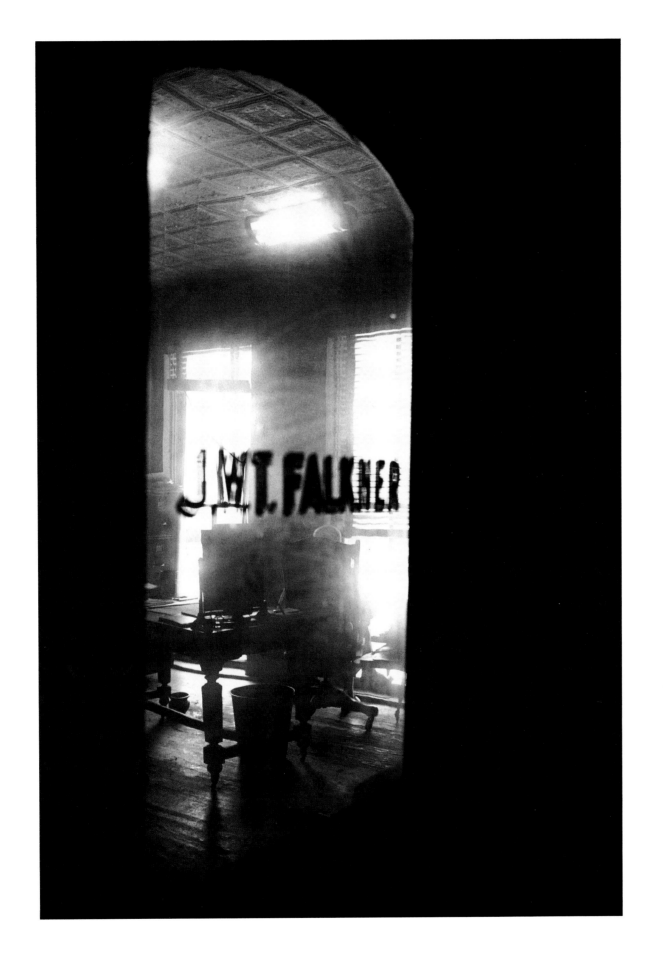

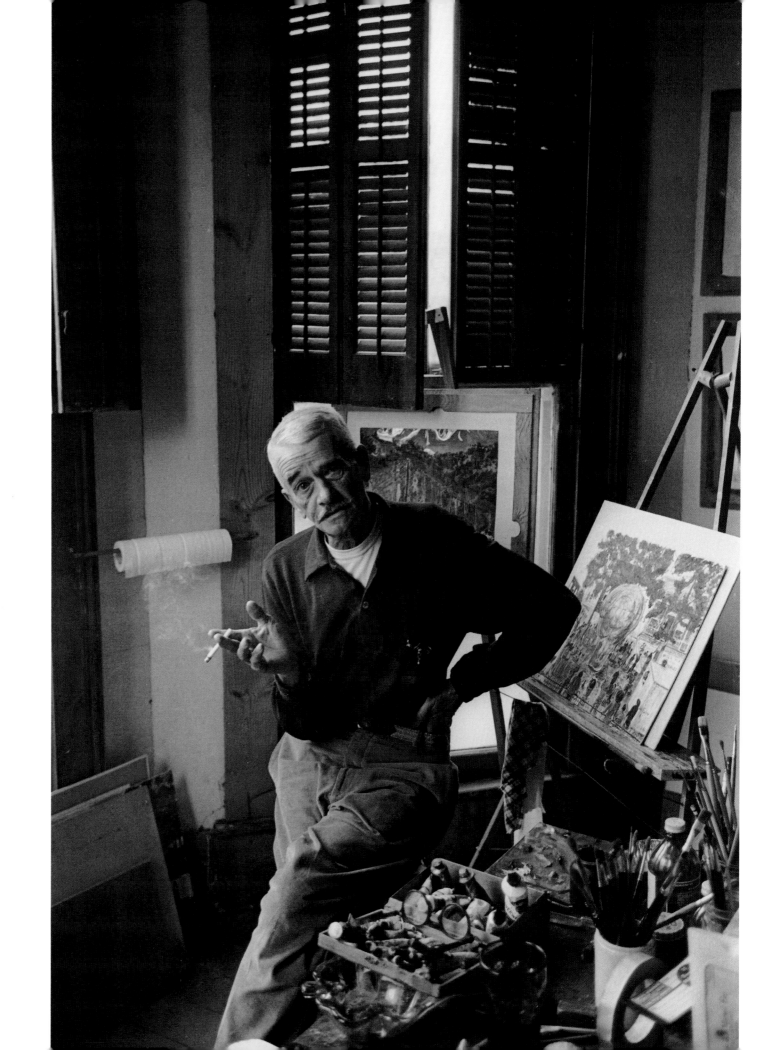

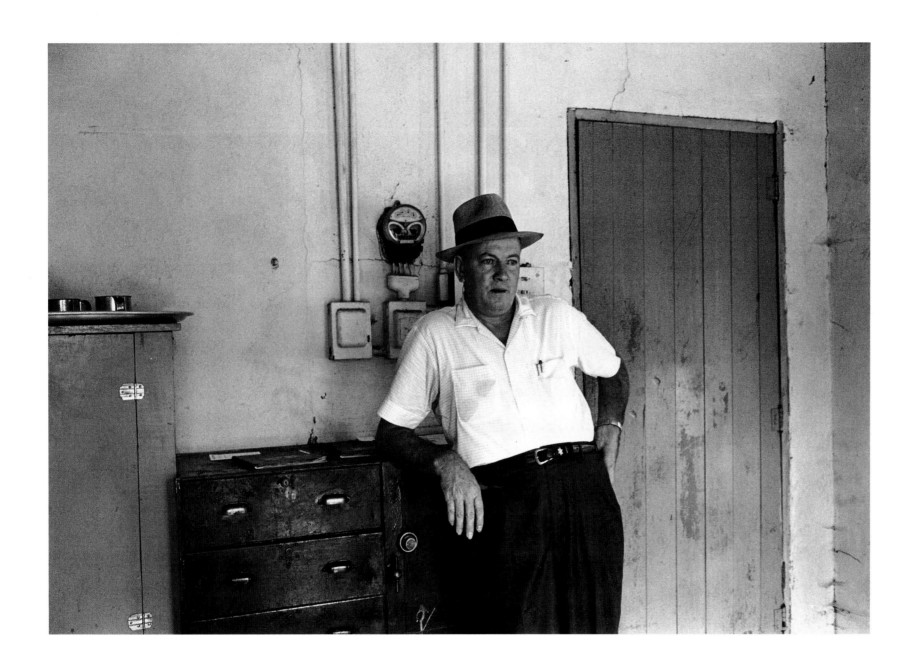

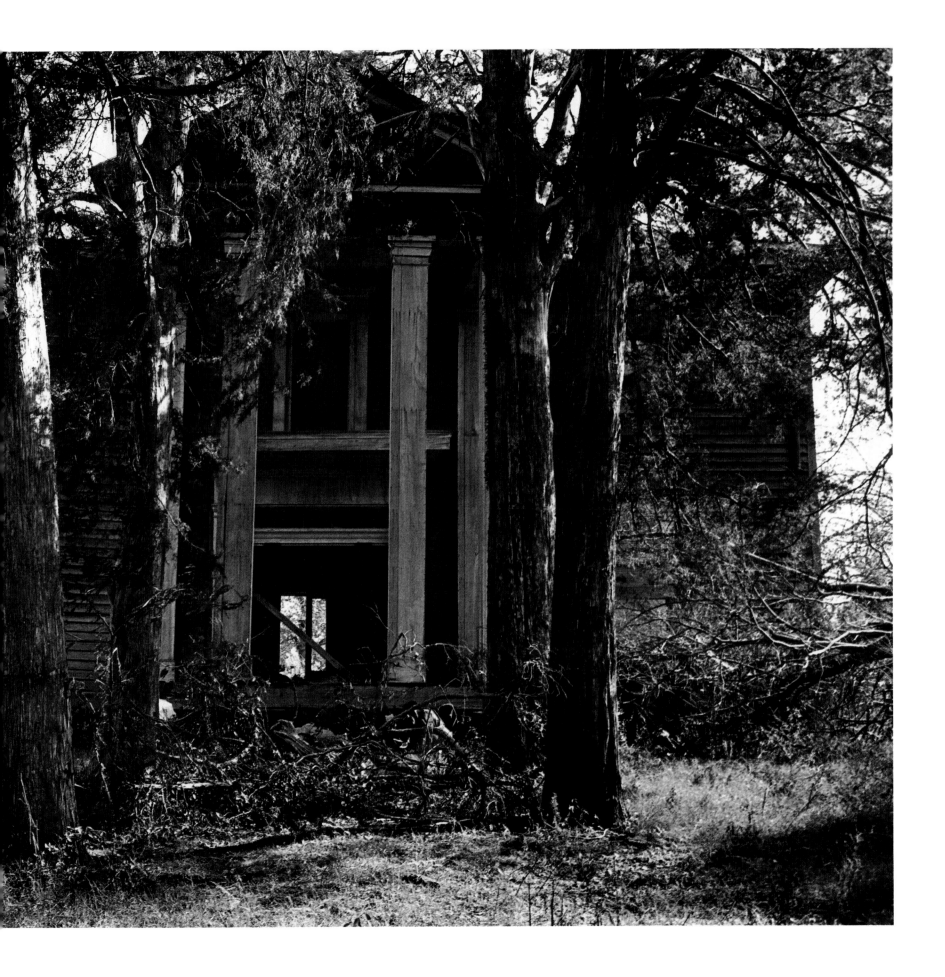

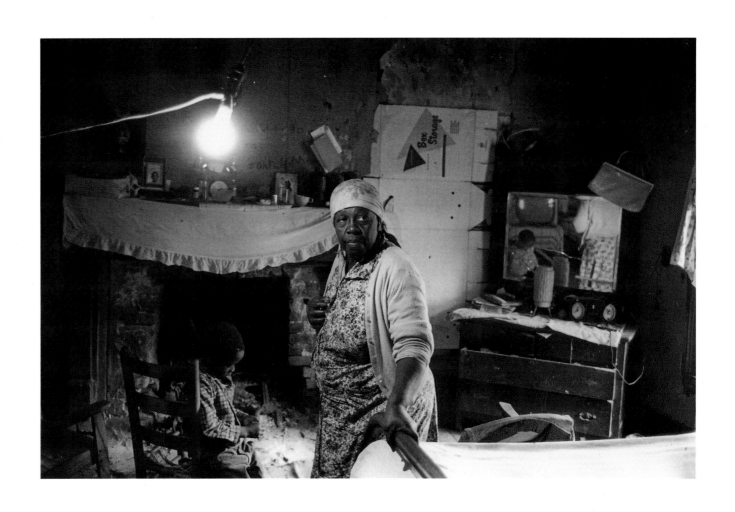

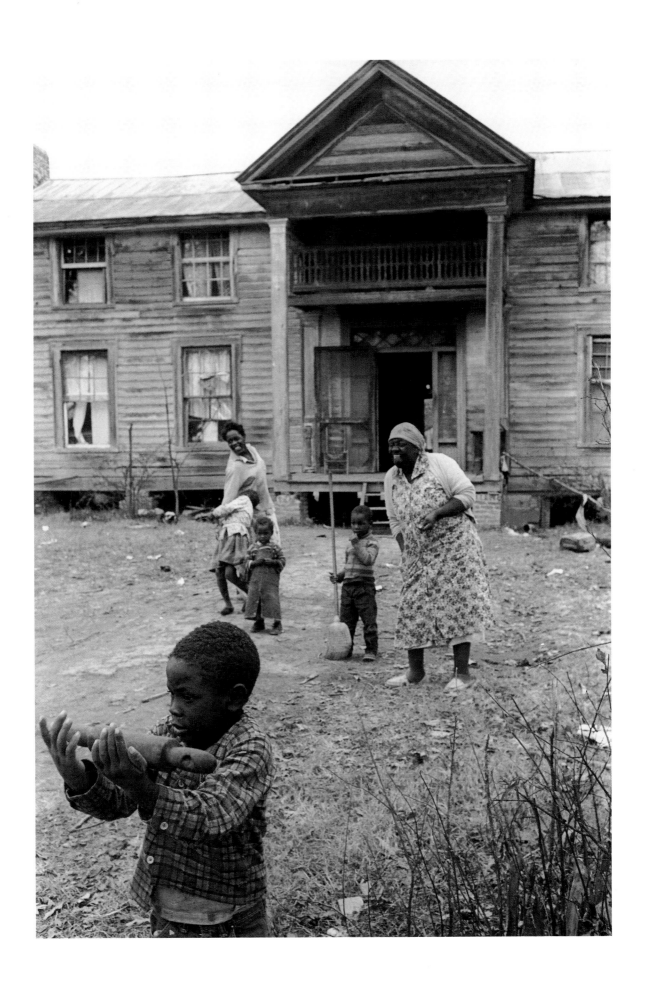

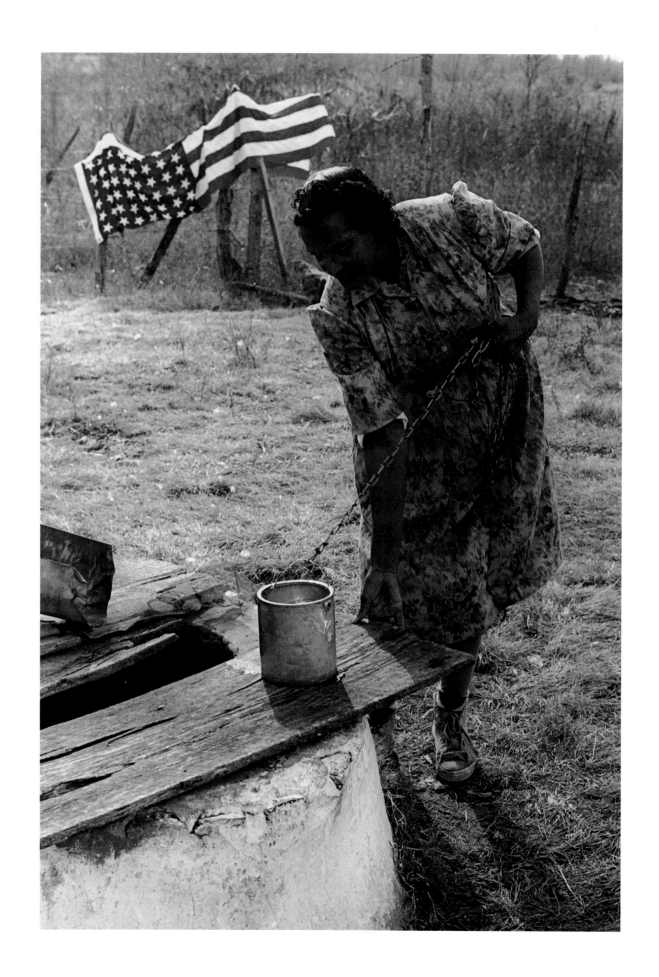

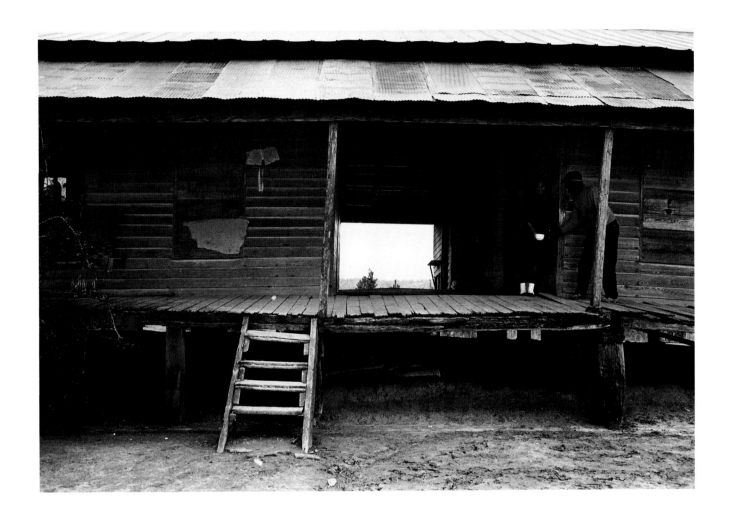

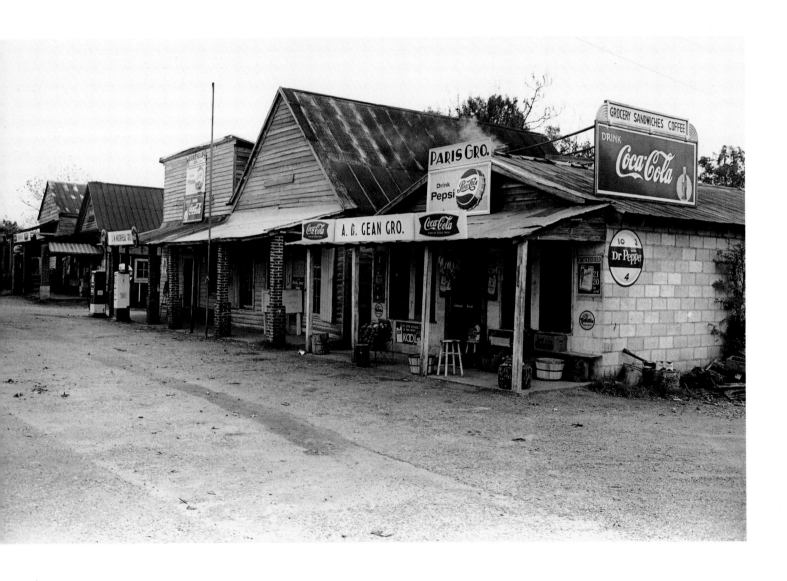

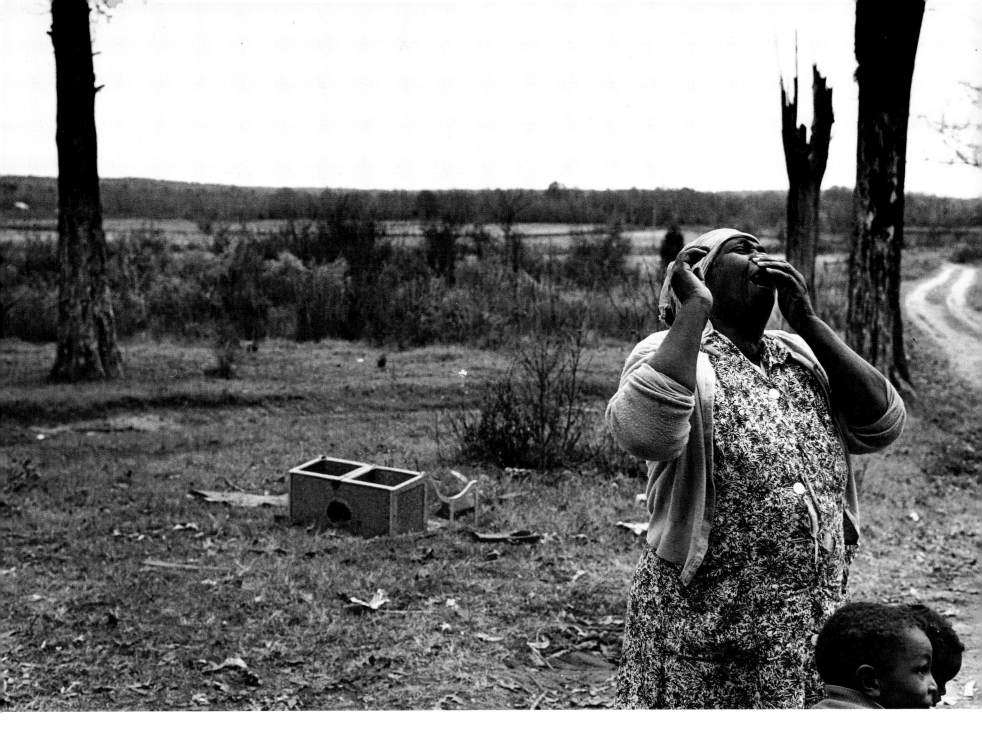

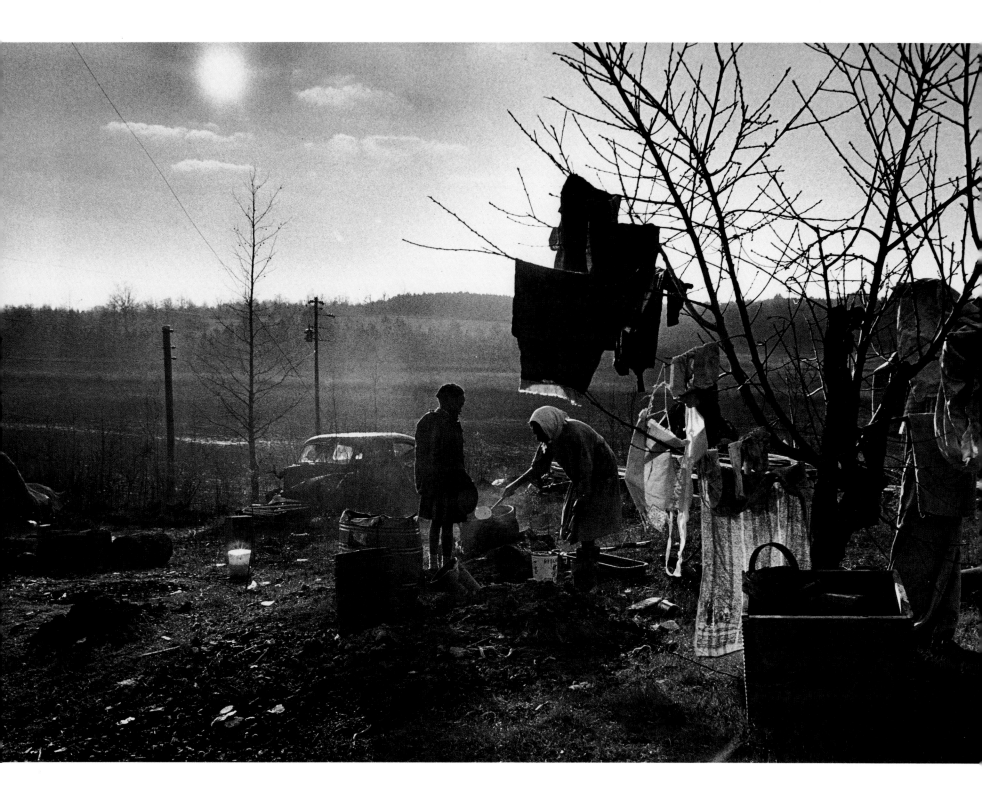

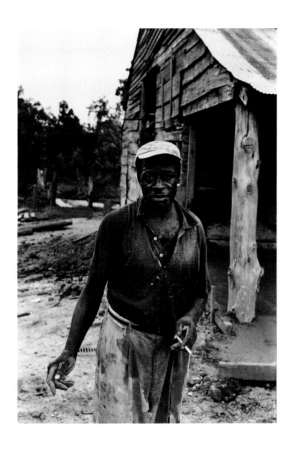

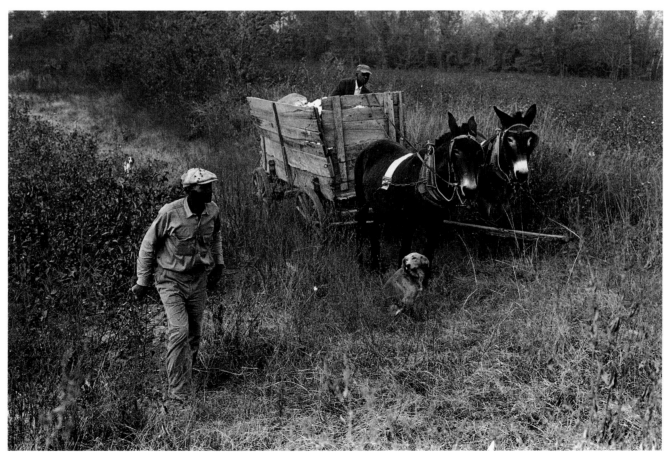

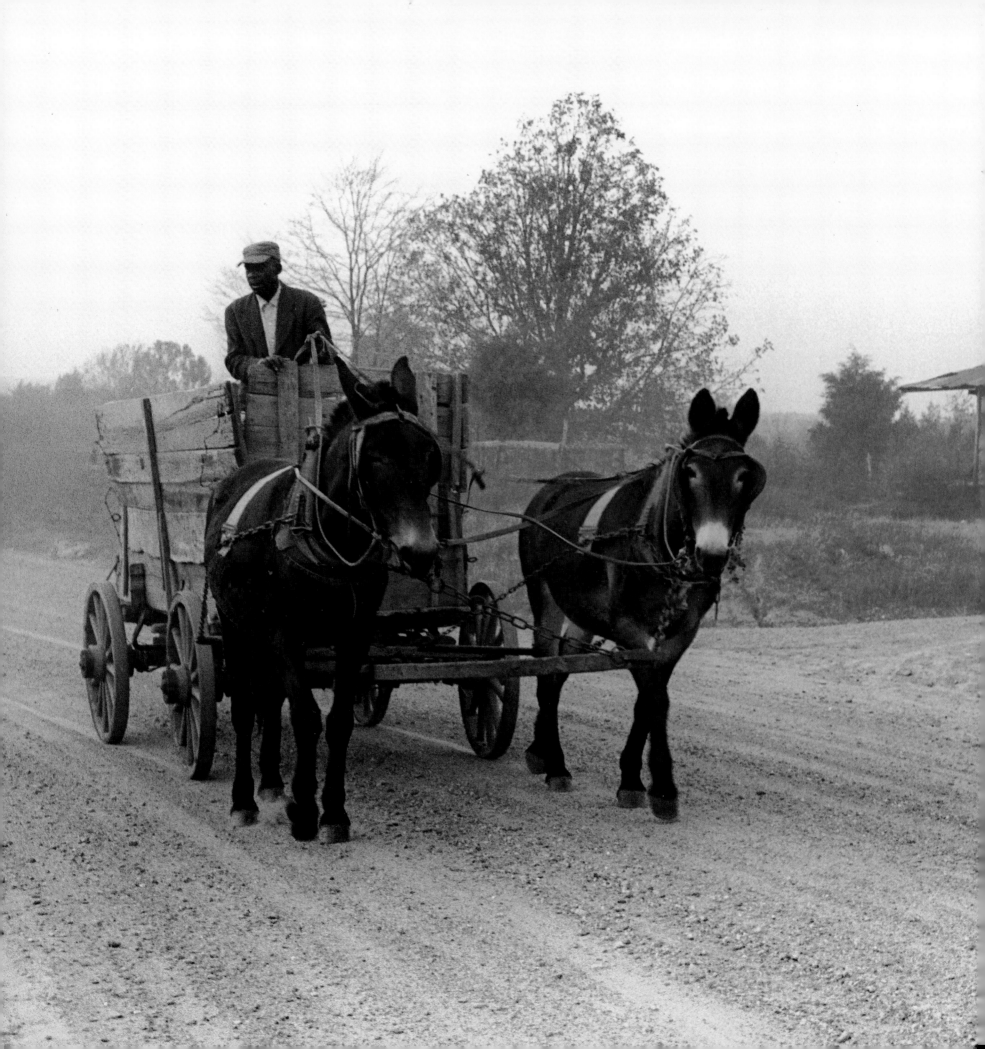

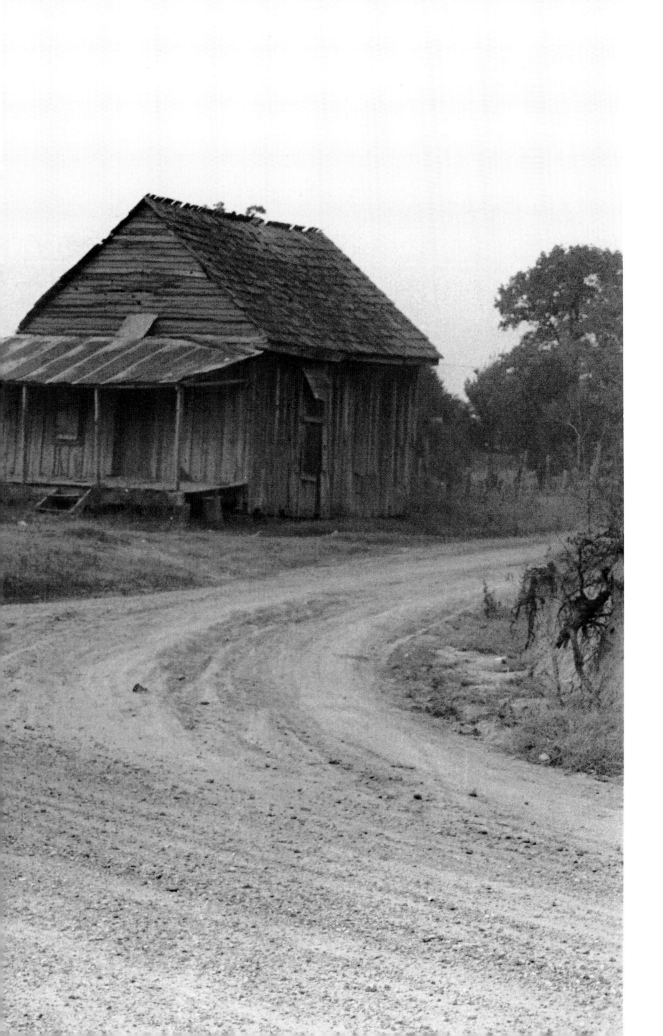

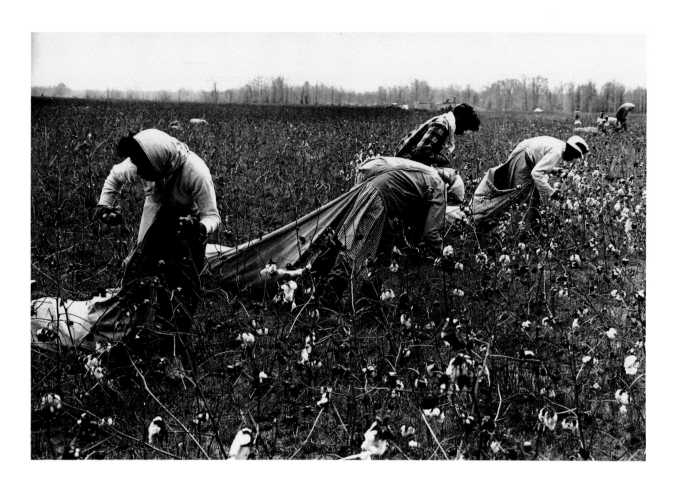

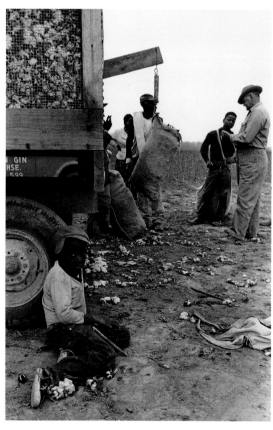

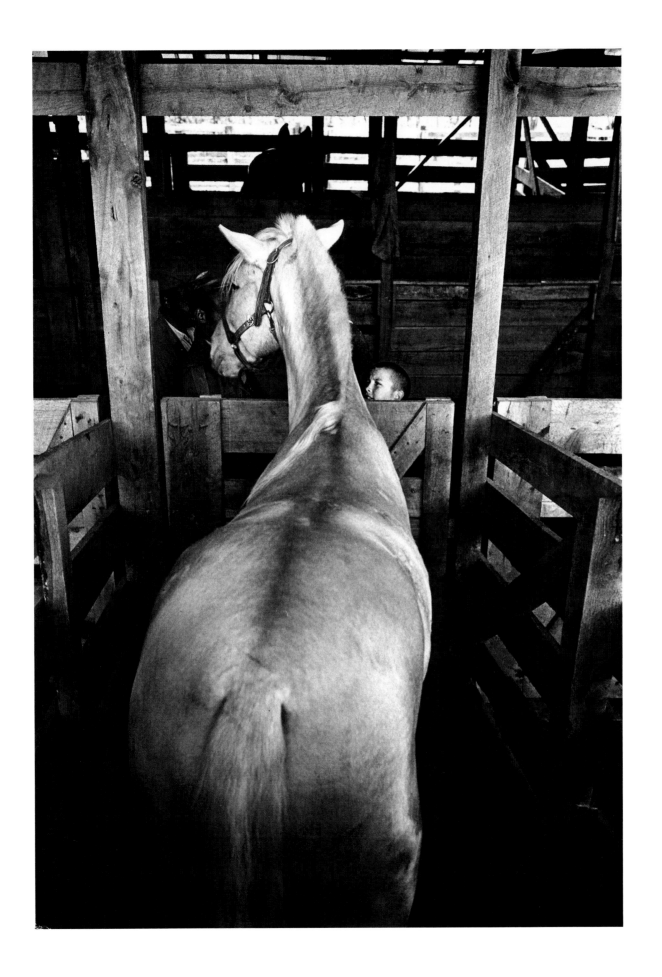

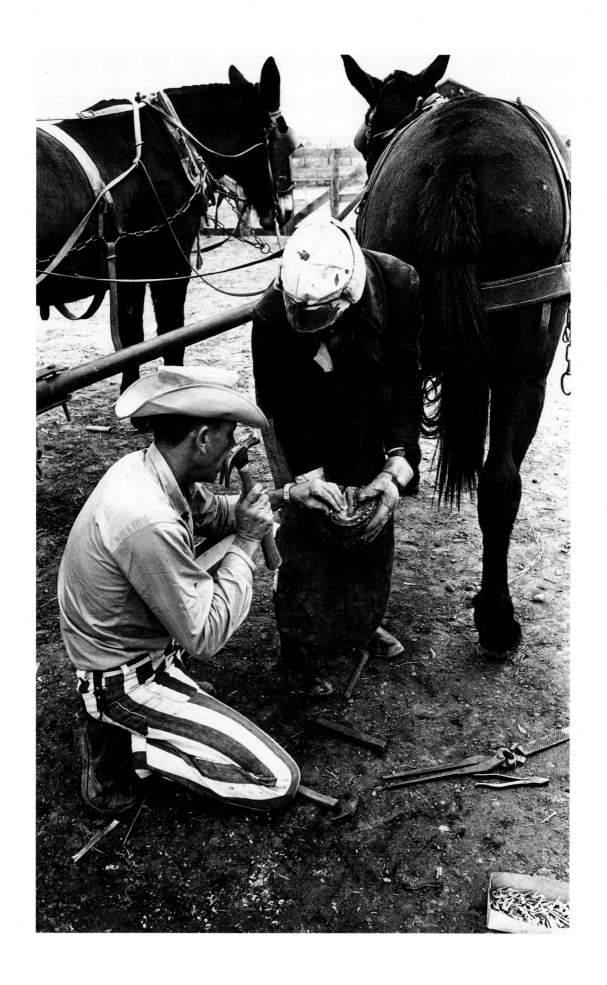

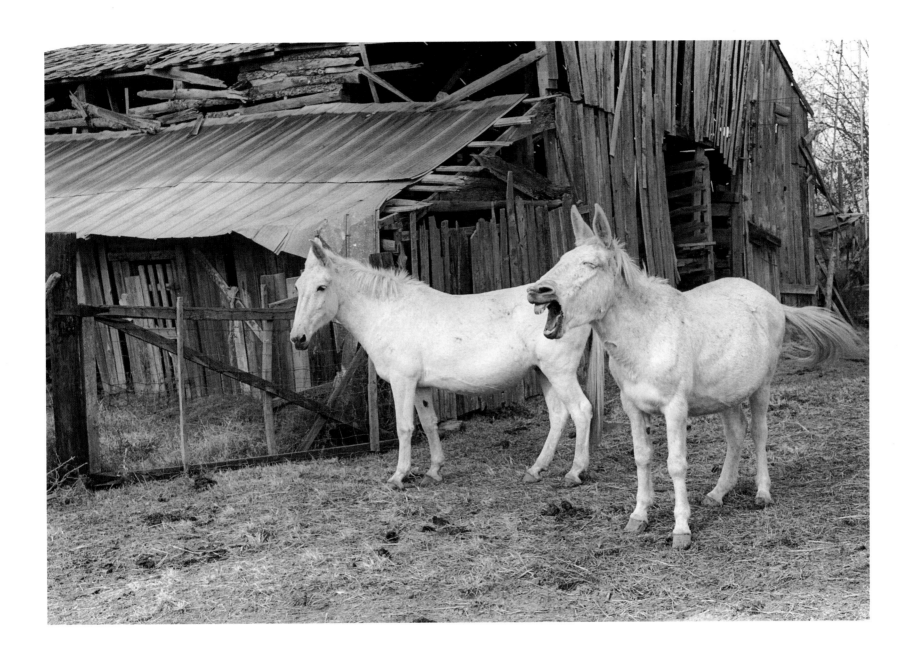

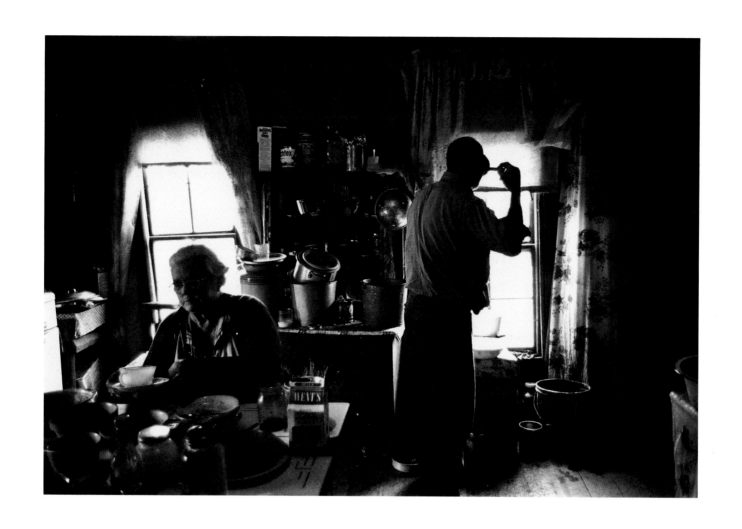

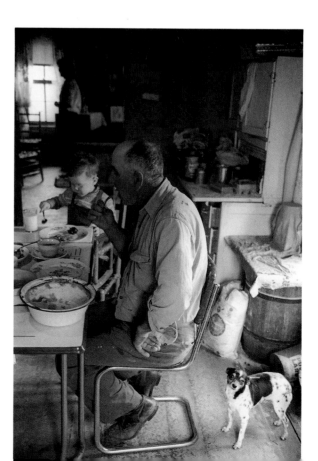

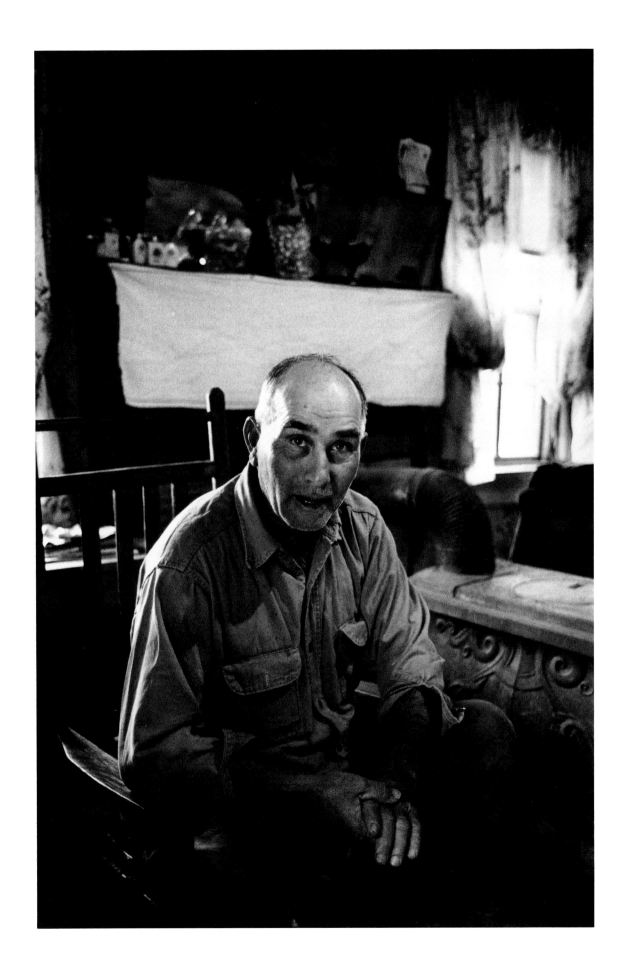

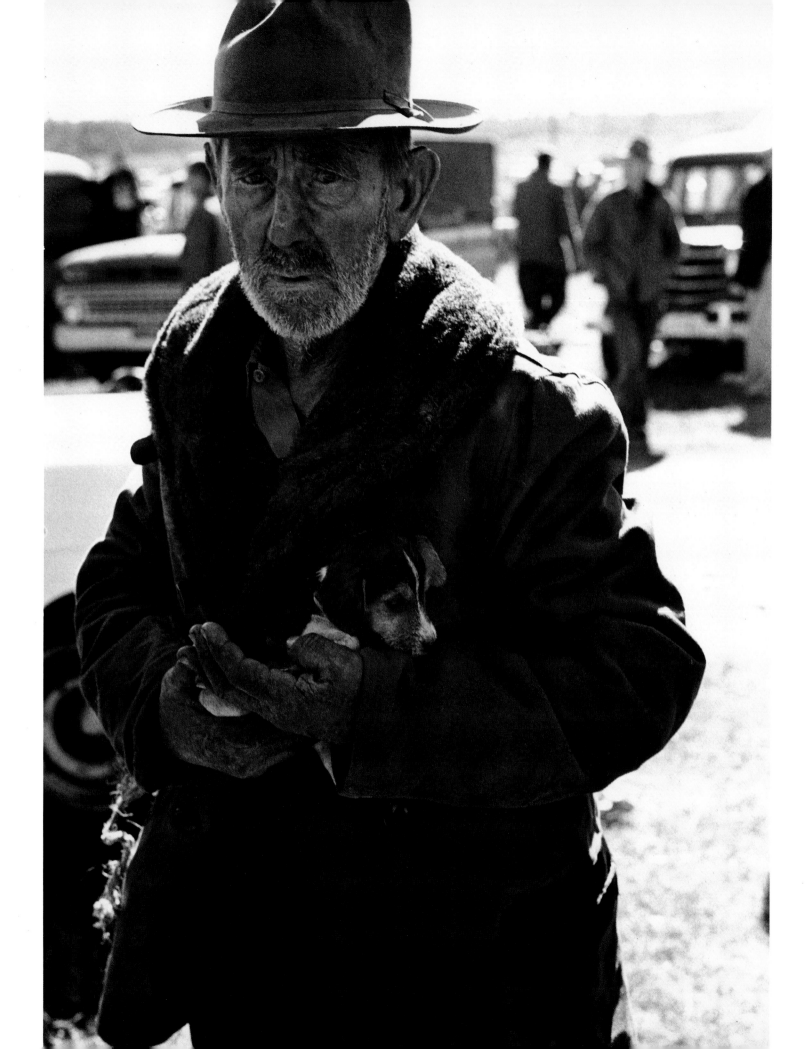

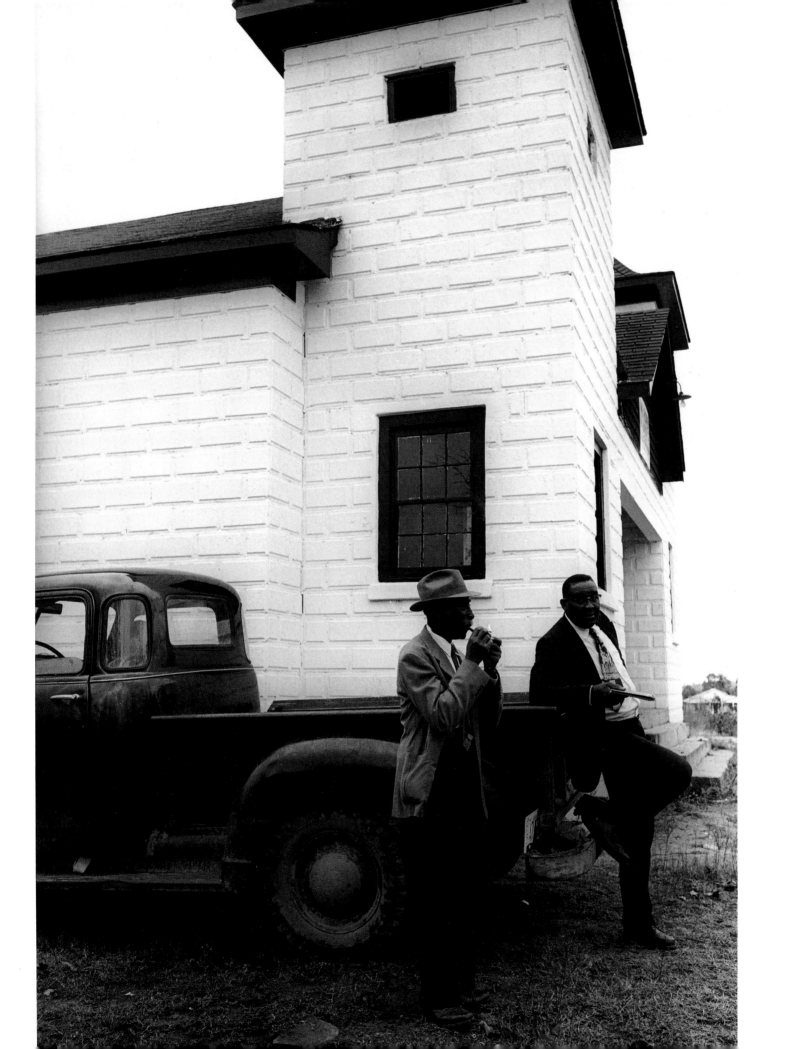

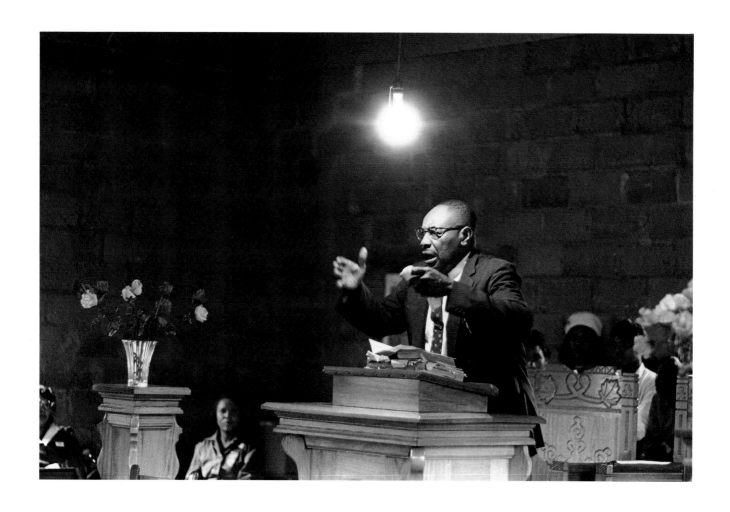

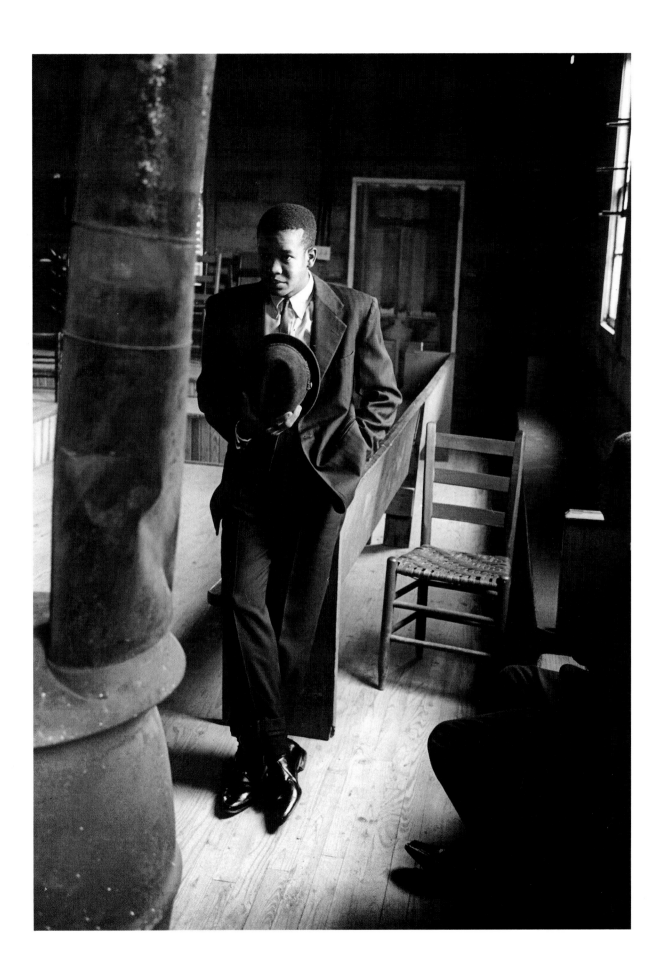

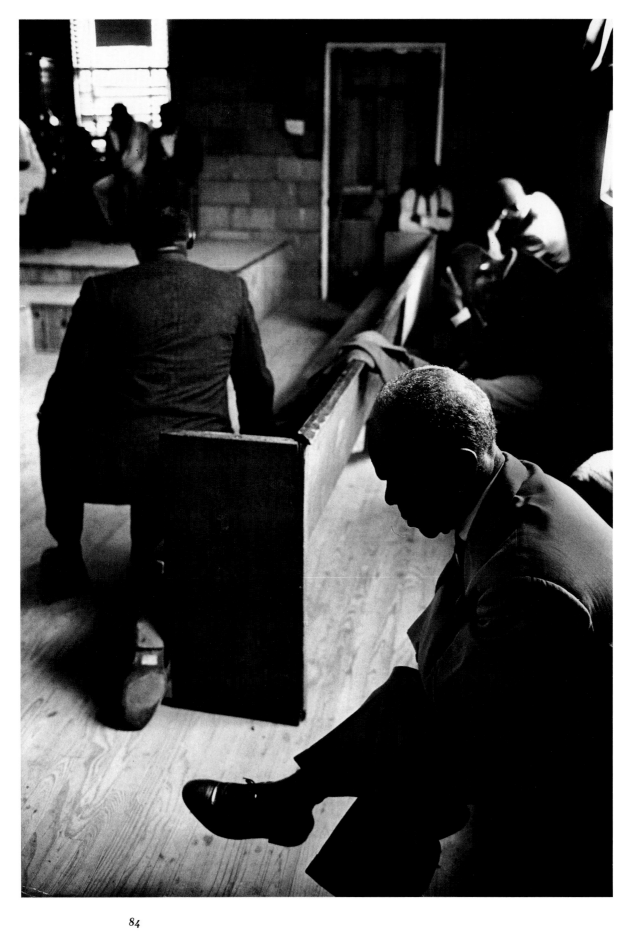

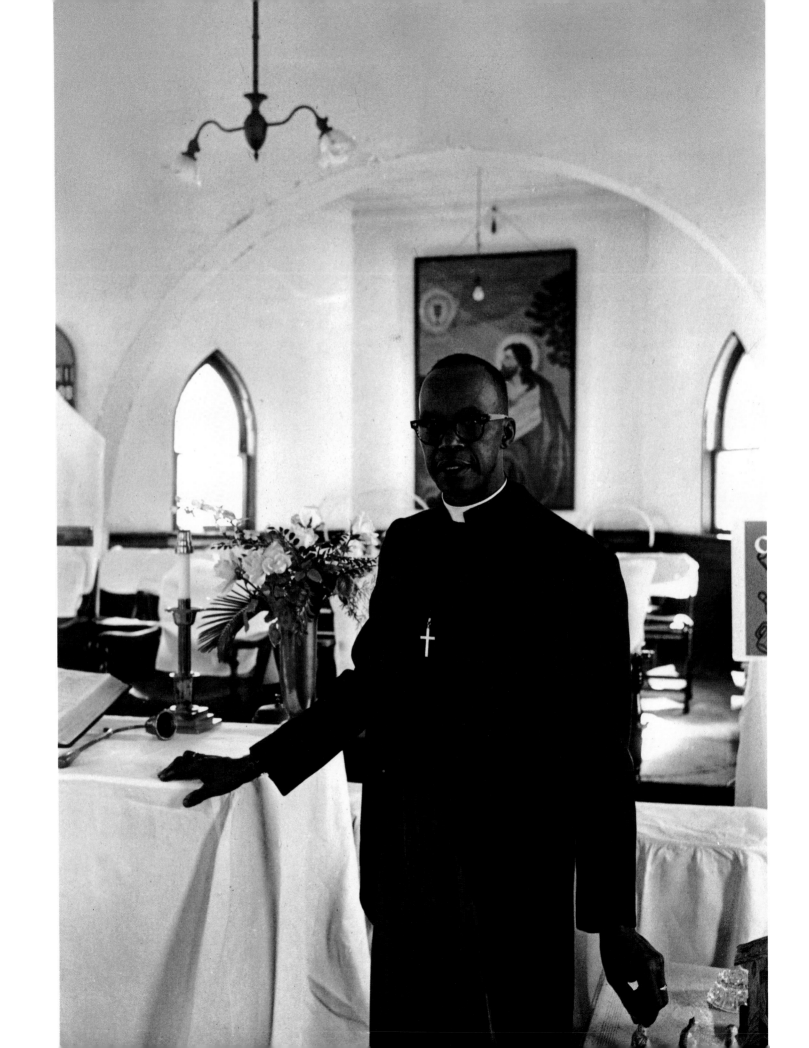

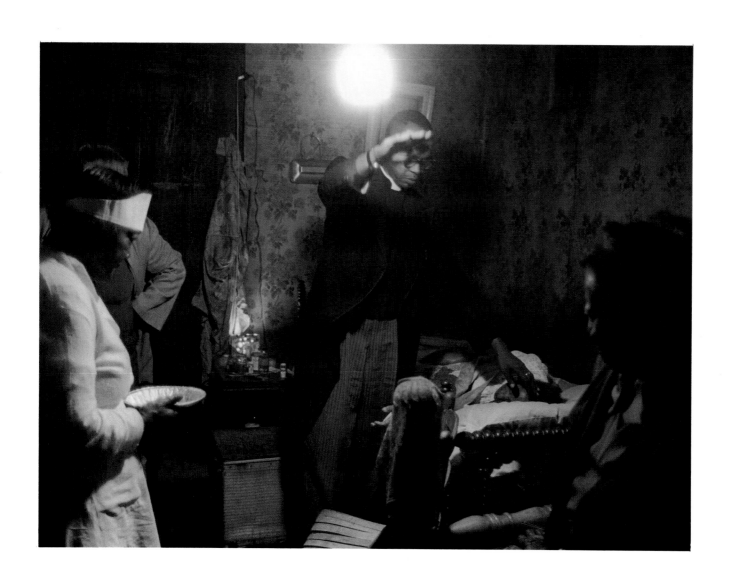

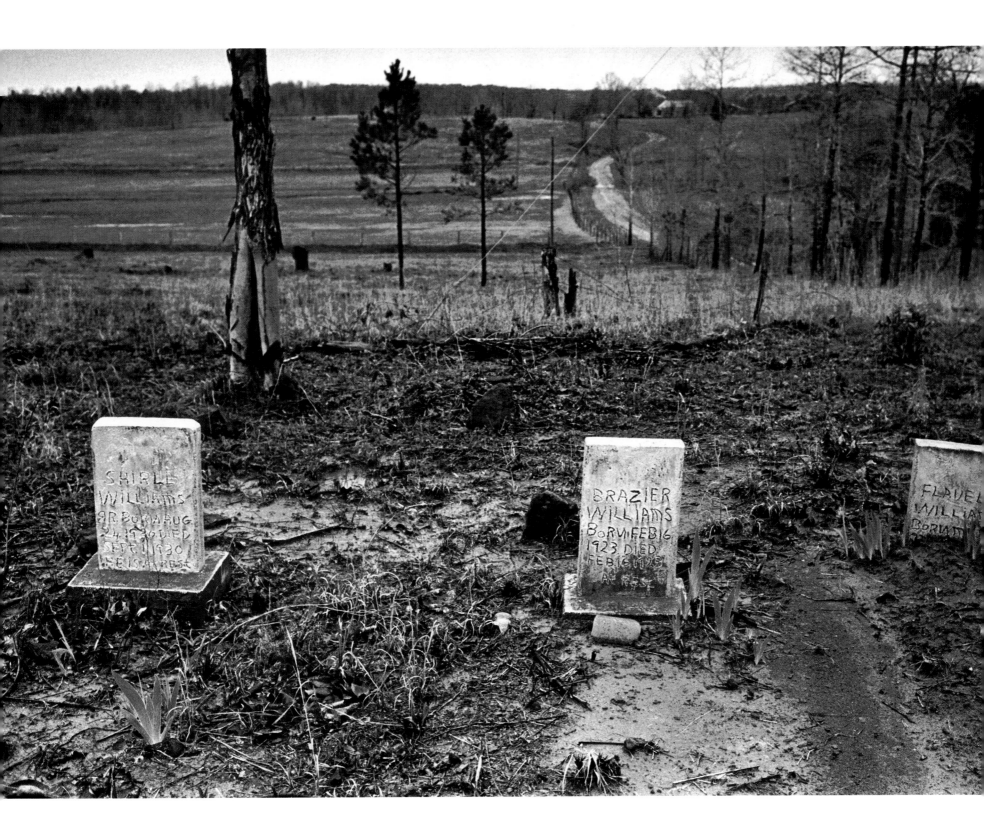

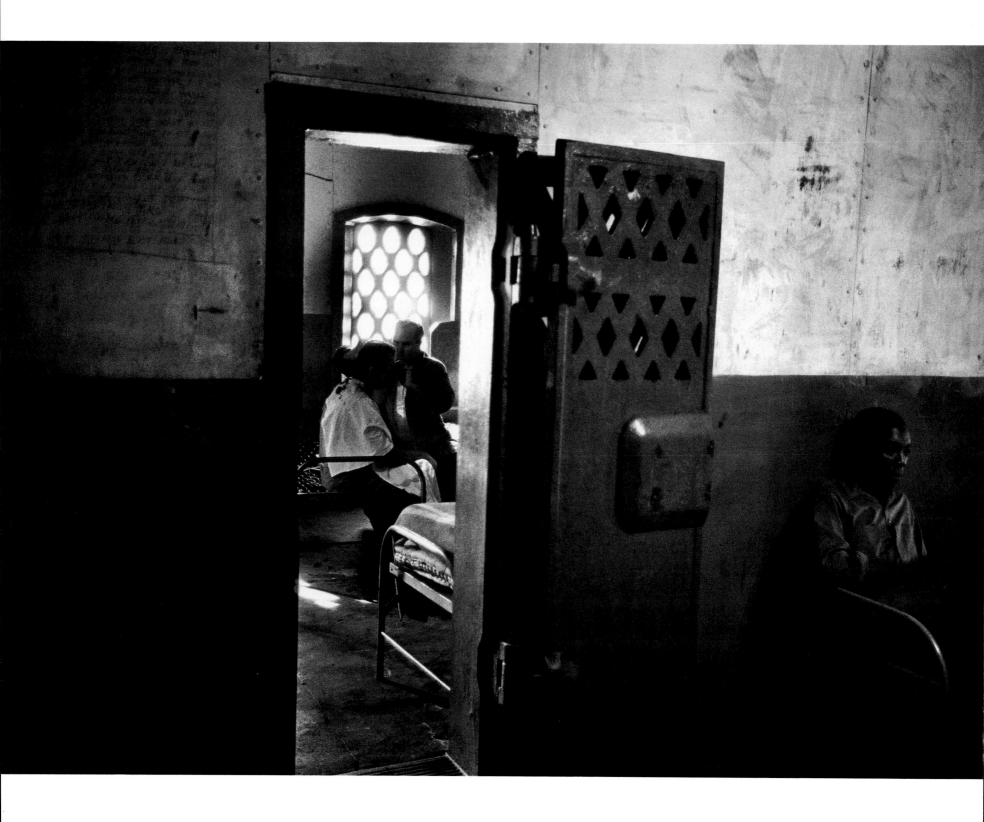

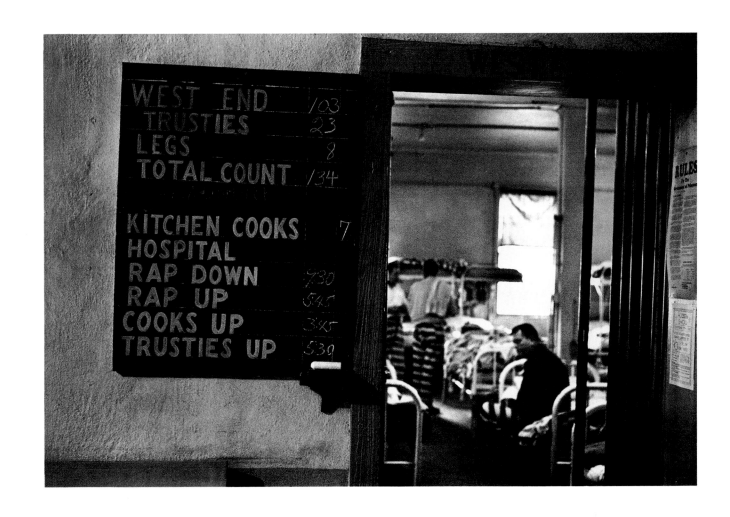

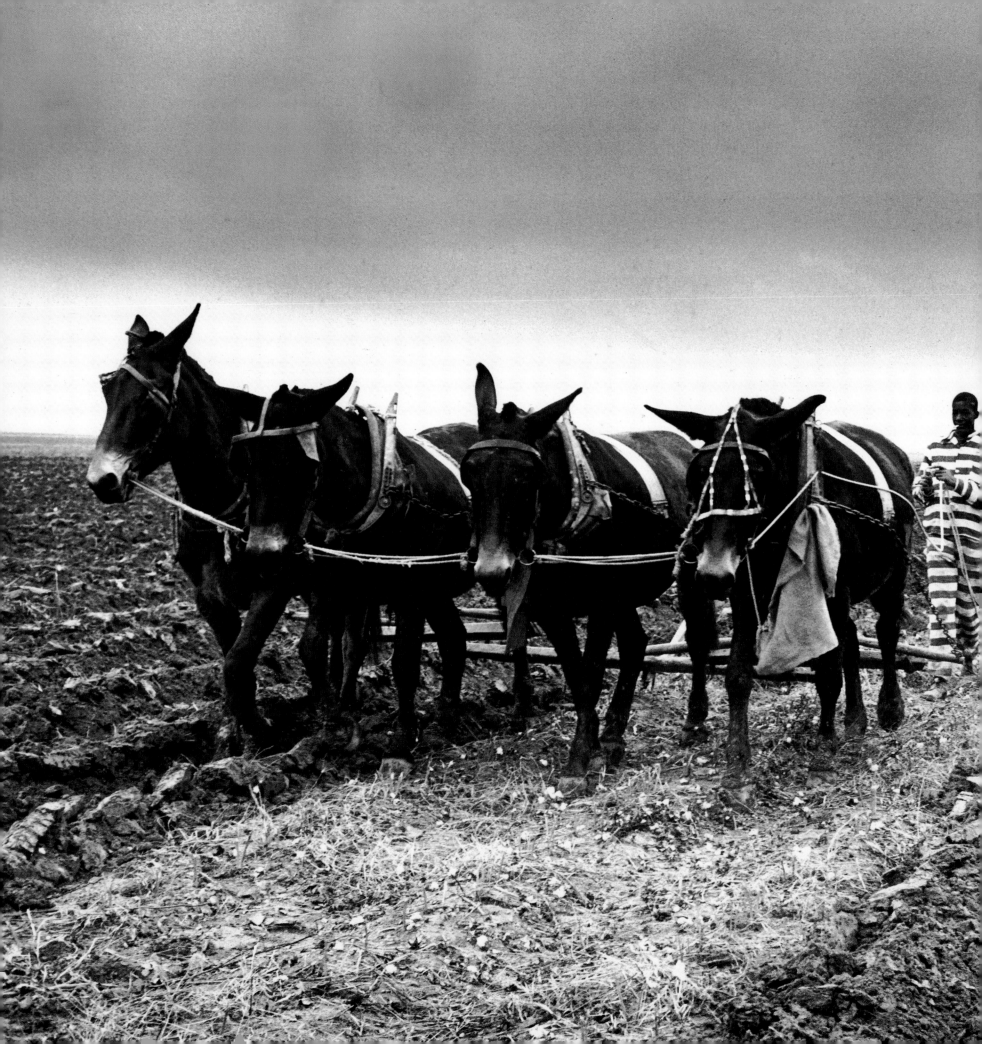

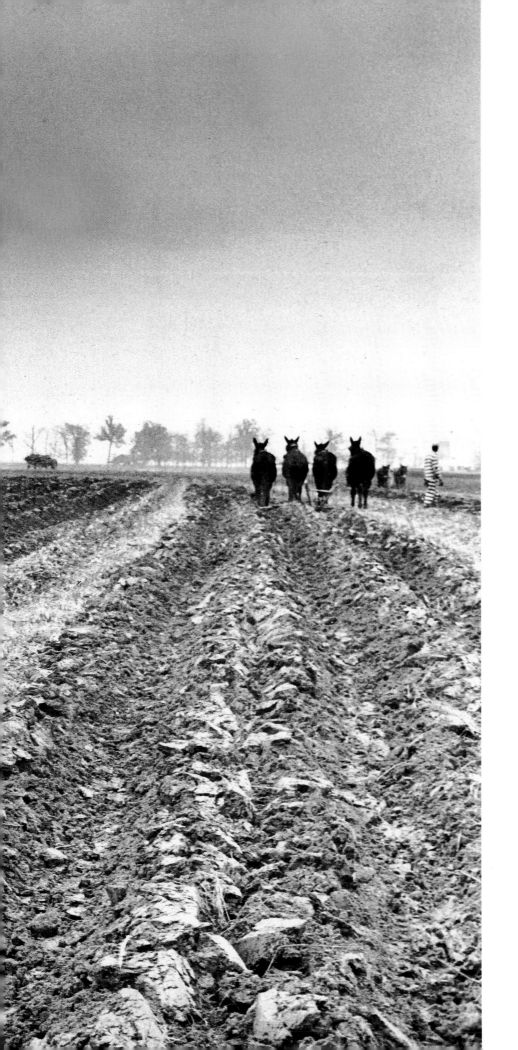

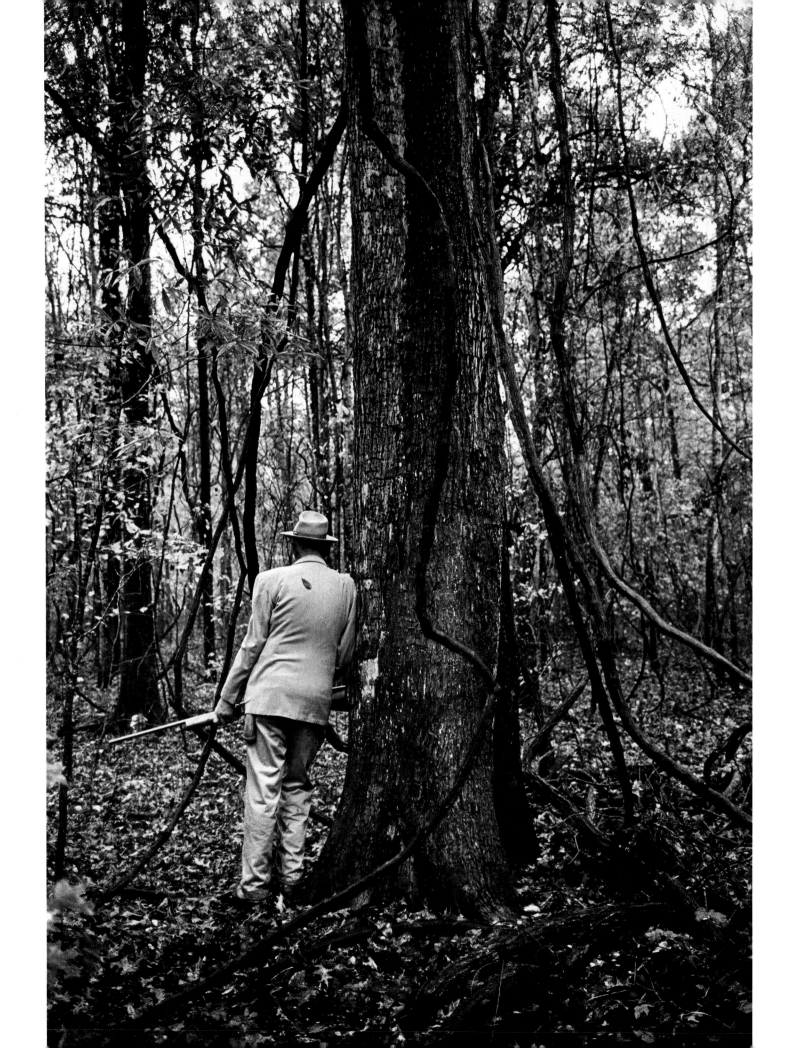

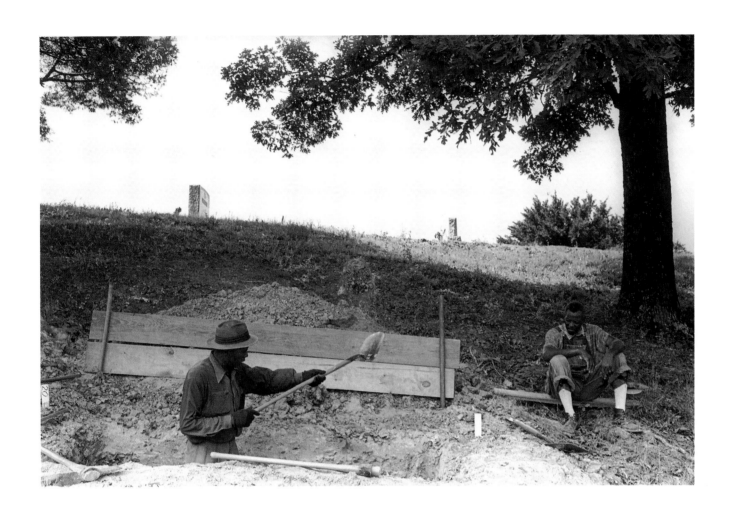

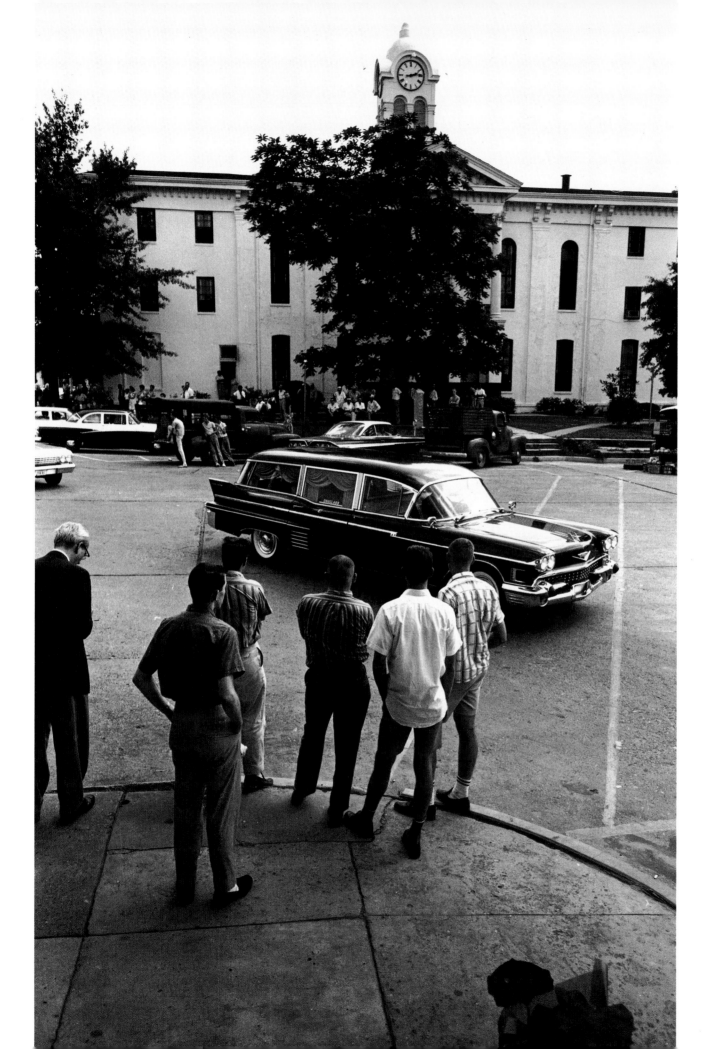

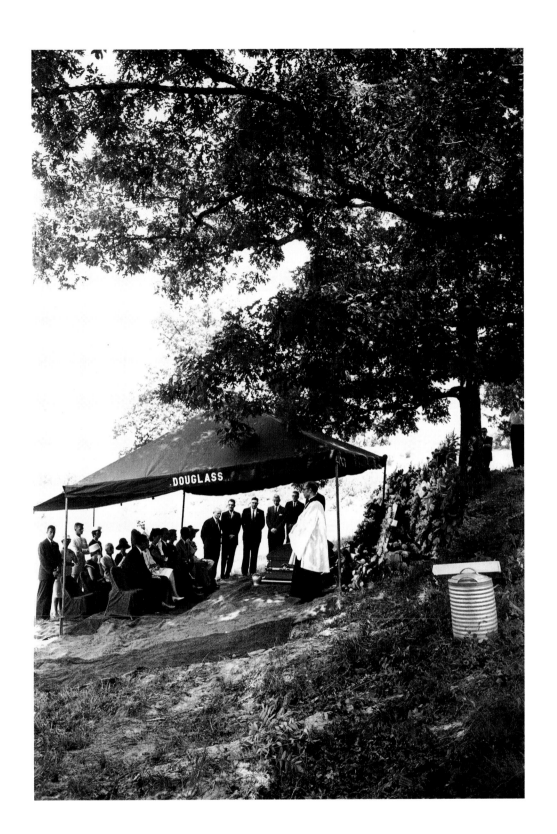

Notes on the Photographs

Pages 18-19 Early evening in August, the sun still hot and the air heavy. The Confederate statue faces south; behind it is the Lafayette County Courthouse, Oxford

Page 20 A view of the Courthouse Square.

Page 21 The base of the statue of the Confederate soldier.

Page 22 Southeast corner of the Square (top). The northwest corner of the Square (bottom).

Page 23 On Saturdays, the shopping and general meeting day, country and town folk gathered on the Square.

Page 24 Men often sat in the hall of the county courthouse during all seasons.

Page 25 The sidewalk in front of the law offices of Judge John Wesley Thompson Falkner II, William Faulkner's uncle.

Page 26 Local farmers used to sell fruit and vegetables at stands surrounding the Courthouse Square, especially on Saturdays.

Page 27 View in front of the Federal Building, which houses the post office. In the northwest corner of the Square, the old Federal Building is now Oxford City Hall (top). Saturday around the Square looking from Blaylock's Drugstore, now Square Books.

Page 28 In an alley to the side of Phil Stone's law office, just off the Square, were African American businesses, including this restaurant, the B&B Cafe.

Page 29 Looking south from the Courthouse on an early December evening.

Page 30 Charlie Lawhorn dozes on a bench in the shade of trees by the Courthouse.

Page 31 Bud Miller, one of Faulkner's hunting companions.

Page 32 Mac Reed in Gathright-Reed Drugstore.

Page 33 In and about the law offices of Judge John Wesley Thompson Falkner II, Faulkner's uncle.

Page 34 John Wesley Thompson Faulkner III, William Faulkner's younger brother. A novelist and a painter, he is shown in his studio in Memory House, Oxford, where he lived until his death in 1963.

Page 35 A former deputy sheriff.

Page 36 Woman with lard bucket.

Page 37 Mrs. Maud Brown, a local church historian, who was credited with recognizing Faulkner as a poet in the early twenties.

Page 38 "Colonel" J. R. Cofield, photographer, and Mac Reed, pharmacist, in the Cofield Studio, Oxford.

Page 39 Bill Evans, a retired farmer, carpenter, and painter. When this portrait was made, he was sixty-five.

Page 40 Twins Eph and Ed Lowe, surveyors and connoisseurs of vintage automobiles.

Page 41 Student at a rural school.

Page 42 Yocona Vocational School, Yocona, Mississippi, southeast of Oxford (top). Principal W. N. Redmond, Abbeville Elementary School (bottom).

Page 43 Abbeville Elementary School, Abbeville, Mississippi, north of Oxford.

Page 44 College Hill Presbyterian Church, just a few miles northwest of Oxford.

Page 45 The Reverend Duncan M. Gray, Jr., rector of St. Peter's Episcopal Church. Mr. Gray preached William Faulkner's funeral.

Pages 46-47 The Shipp Place, an abandoned antebellum structure, southeast of Oxford.

Pages 48-49 The Jones-Miller Place, an antebellum house, then inhabited by Mrs. Book and her family, southwest of Oxford.

Page 50 This flag was drying in the sun, having been washed for the local school. The woman draws water from a well.

Page 51 Dogtrot house, Lafayette County.

Page 52 Paris Grocery, Paris, Mississippi, south of Oxford.

Page 53 Mrs. Book at the Jones-Miller Place.

Page 54 Laundry scene, Lafayette County.

Page 56 On a November evening this man returns to his home in his cotton wagon.

Pages 58-63 Cotton picking scenes. The fields were too wet for mechanized harvest and the cotton was also poor that year.

Page 59 shows E. W. Wells handpicking his cotton.

Pages 64-66 Tommy Bounds was an itinerant salesman for Watkins Products. His routes took him deep into the county. He sold a variety of items: liniment, spices, toilet articles, insecticides, vitamins for animals and people. At the time, Bounds had about 450 customers and had been a salesman for twenty years.

Page 67 Corn crib, Lafayette County.

Page 68 Portrait of John Cullen, member of a longstanding Lafayette County family and a colorful columnist for the *Oxford Eagle*.

Page 69 Store scene, Lafayette County.

Page 70 Sorghum molasses making in the early fall.

Page 71 Hog killing and butchering (top). John Cullen feeding his hogs (bottom).

Page 72 M. R. Hall, a blacksmith in the community.

Page 73 Livestock auctions took place every Monday on the outskirts of Oxford.

Page 74 Farrier at Parchman Penitentiary.

Page 75 Lafayette County scene.

Pages 76-77 E. W. Wells, his wife, and grandson. He was farming 156 acres of land, some of it badly eroded. With government help he was trying to save the land. In 1962 his 8.5 acres of cotton yielded ten bales. He picked his crop with the help of his son-in-law.

Page 78 Man with puppy.

Pages 81-84 Mt. Hope Baptist Church. On page 81, the man standing on the right at the back of the truck is Mr. Linder Burt; page 82 shows the pastor, the Reverend C. I. Bulloch.

Pages 85-86 The Reverend W. N. Redmond, Burns Methodist Church, Oxford. He was also the principal of the black elementary school in Abbeville. A friend of James Meredith, Mr. Redmond was very active in the community.

Page 87 Rural graveyard, Lafayette County.

Page 88 The jail, built around 1870, was on the top floor, and the bottom floor housed the deputy and his family.

Page 89-91 The state penitentiary at Parchman, about 100 miles southwest of Oxford.

Page 93-97 Deer hunts occurred most frequently during Thanksgiving and Christmas weeks. Many people hunted in the Delta. On this hunt, the camp boss blew his horn to signal the beginning of the hunt. As the dogs trailed the deer, the men, waiting in their solitary stands since sunup, watched for a buck.

Page 99 Rowan Oak, William Faulkner's home.

Page 100 Andrew Price, William Faulkner's gardener and general helper.

Page 101 Faulkner's study at Rowan Oak, where he painted an outline of his novel *A Fable* on the wall.

Page 102 William Faulkner with Victoria Fielden Johnson, his stepgranddaughter.

Page 103 Faulkner with Fielden and a dog by his horse lot.

Pages 104-06 Faulkner leading a favorite horse into his hand-hewn barn.

Page 107 Preparing William Faulkner's grave, St. Peter's Cemetery, Oxford.

Page 108 Hearse carrying Faulkner around Courthouse Square.

Page 109 Funeral service, Rev. Duncan M. Gray, Jr., officiating.

Acknowledgments

First, I must acknowledge Martin J. Dain, whose photographs this book presents and celebrates. He had the vision and passion to make over 8,000 images in his attempt to reveal the world of William Faulkner. I appreciate Dain's willingness to have his photographs archived, preserved, and made available to the public in the place of their origin, Oxford and Lafayette County, Mississippi. The Martin J. Dain Collection, housed in the Southern Media Archive at the Center for the Study of Southern Culture, will forever provide an in-depth visual document of Faulkner's community in the early 1960s.

This book would not have been possible without the abiding interest and commitment of Provost Gerald Walton, whose support led to publication. Ann J. Abadie, Associate Director of the Center, has worked steadily to help secure the Dain Collection, to help shepherd the idea of this book through to reality, and to provide her characteristically sharp editorial perspective at every turn. She deserves much credit. William Ferris and Charles Reagan Wilson also lent their insight and support. Thanks to Karen Glynn for organizing and caring for the Dain photographs,

and thanks to those who helped identify persons in them: Vasser Bishop, John Bounds, Mrs. Queenie E. Dixon, Betty Hoar, Aston Holley, Richard Howorth, and Sarah Dixon Pegues. When I first thought about the concept of this book, I had in mind a foreword by Larry Brown. I appreciate Larry's willingness to open this book with his eloquence. The reproductions in this book were produced from Dain's vintage prints and from prints made by Dan Sherman and me. Dan particularly worked diligently and meticulously to print the accompanying traveling exhibition. Thanks also to JoAnne Prichard, executive editor at University Press, for supporting my ideas and enduring my work habits. And to John Langston, my favorite book designer, for his good work.

Finally, unlimited gratitude must go to the many people of Oxford, Lafayette County, and surrounding areas—some known, others unknown—who collaborated with Martin Dain to first make these photographs. Those pictured here, and many more not shown, graciously let him into their lives so that he could accomplish his vision. This book is dedicated to each and every one of them.

Tom Rankin
Center for the Study of Southern Culture
University of Mississippi